Published in Great Britain in MMXVII by
Book House, an imprint of
The Salariya Book Company Ltd
25 Marlborough Place, Brighton BN1 1UB
www.salariya.com
www.book-house.co.uk

ISBN: 978-1-910706-64-0

SALARIYA

1 3 5 7 9 8 6 4 2

A CIP catalogue record for this book is available
from the British Library.

Printed and bound in China.

QUiCK DRAW ™

Sarah Wimperis

BOOK HOUSE
a SALARIYA imprint

CONTENTS

CHAPTER 1
INTRODUCTION

INTRODUCTION

Why draw and paint? Because it's good for you and everyone can do it. Drawing and painting is calming and relaxing. It can also be really exciting when it's going well, and can give you a great sense of achievement. It's a wonderful way to record your travels and is a source of great pleasure. You don't need to be specially gifted, either. All you need is confidence in your ability and that only comes through practice. If you want to improve at anything you must practise. You would hardly expect to be able to play a violin without training. Drawing and painting is no different – you have to learn.

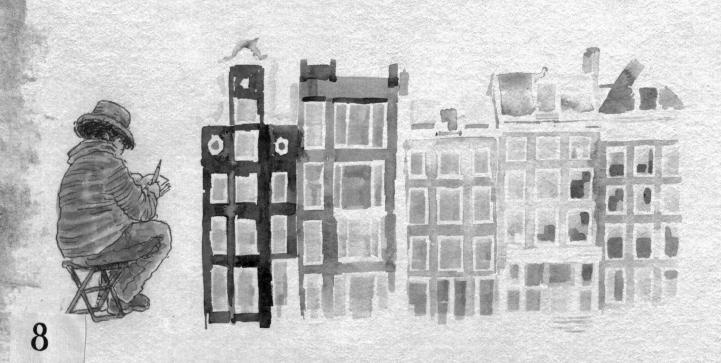

But why would you draw and paint urban landscapes?
Well, more and more of us live in urban areas, or
regularly visit cities. It is where we can see a great
diversity of architecture often peculiar to that one place.
Urban landscapes can be dirty and chaotic, but they
are interesting human spaces. They are fun to draw and
paint and not as complicated as they first look.

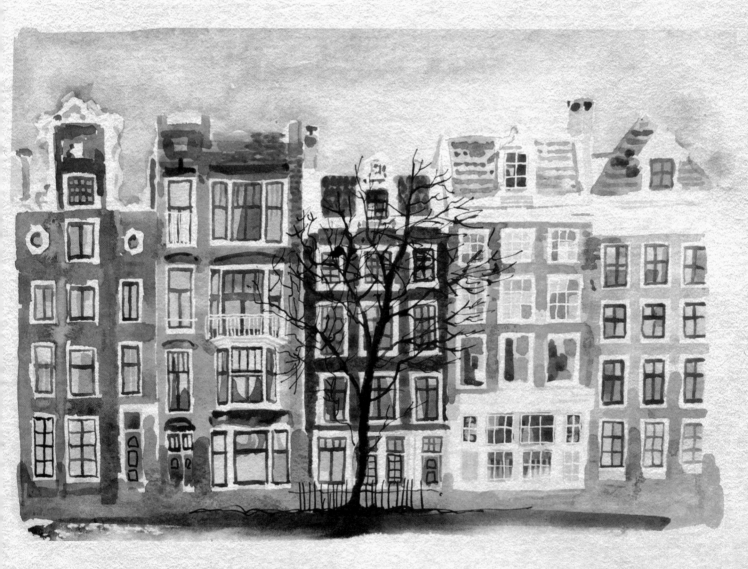

The materials you will need comes down to personal
choice. Practice and experience will guide you.
However, I suggest you begin very simply with a
'pocket sketching kit' – all you really need to get
started is a pen or pencil and a small sketchbook!

HOW TO USE THIS BOOK

First of all, you don't have to do everything in this book. The idea is for you to find something that interests you enough to practise. The interest and desire to try something is the key to becoming more proficient. You will find that your confidence quickly builds and this will become apparent in your drawings and paintings. If you keep practising, that confidence will seep into your bones and you will start to really enjoy painting and drawing.

WHERE TO FIND INSPIRATION

There are hundreds of books on the subject of drawing and painting, a vast array of materials to choose from and more 'styles' of working than you can ever imagine. My advice would be to look around, browse the internet, and become acquainted with other artists' work. When you find a style that you really like or an artist whose work you admire, look into that genre of work to discover more artists you may like. Some may well have a book about how they work or they might have an informative blog or website. Whatever the source, try putting into practice what they teach. That will take effort and perseverance but the results will be worth it. Remember...Rome wasn't built in a day!

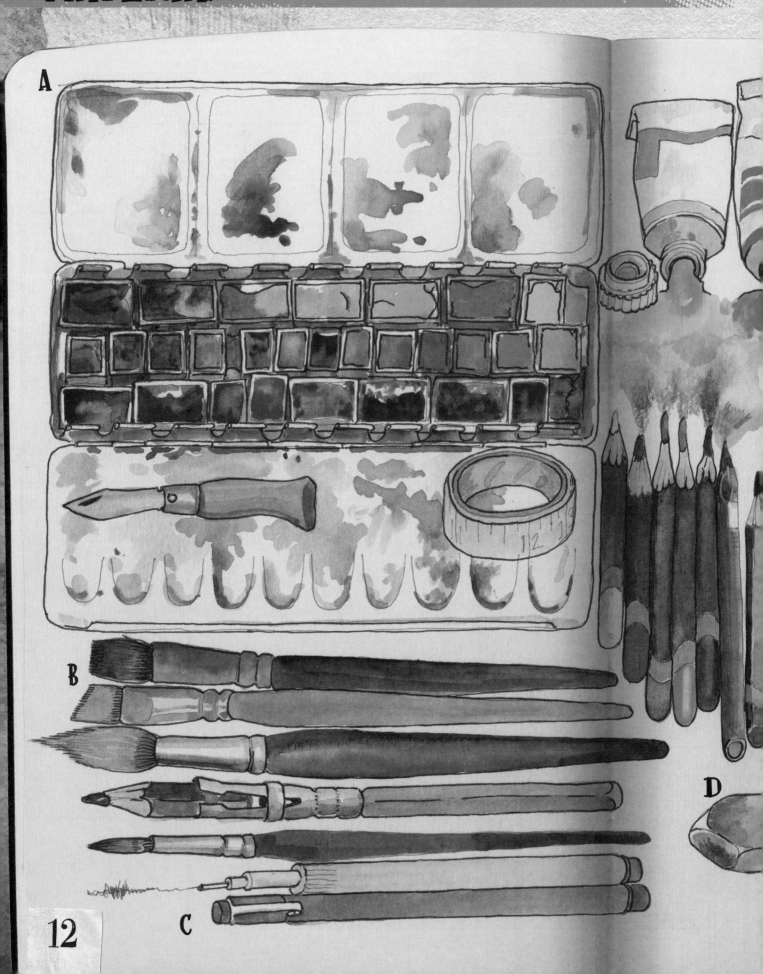

A

B

C

D

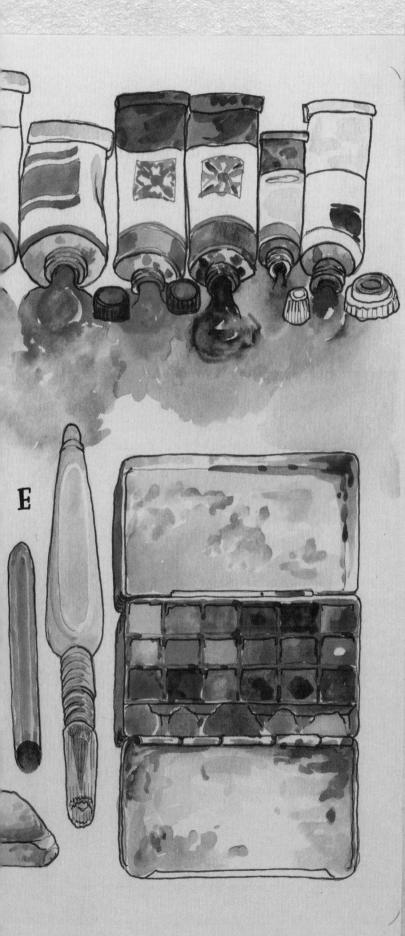

E

A. Watercolour pans or solid blocks are easier to handle because they are laid out in a paint box. However, many painters prefer working from tubes. Watercolour sticks or markers are also available.

B. Paint brushes come in many shapes and sizes and are suitable for a wide range of media. They are made from synthetic fibres or natural hair as in squirrel or sable brushes.

C. Cartridge ink pens with oblique nibs are available in fine, medium and broad widths.

D. Coloured pencils come in a broad spectrum of colours. Water soluble versions can also be used to add a watercolour painting effect.

E. Pencils come in many different grades. The HB or 2B are standard sketching pencils. Choose pencils to suit your style and preference.

MATERIALS FOR SKETCHING

Materials for sketching need to be easily portable and suitable for capturing scenes on the go. Start simply with a sketchbook and pen and gradually build up your sketching 'kit' to suit your needs. Having a good array of useful equipment will let you draw more expressively, but if it's too cumbersome you will be less likely to carry it!

A lightweight sketchbook is ideal to take on your travels. Hard covers can be helpful as they give you a firm surface to lean on.

14

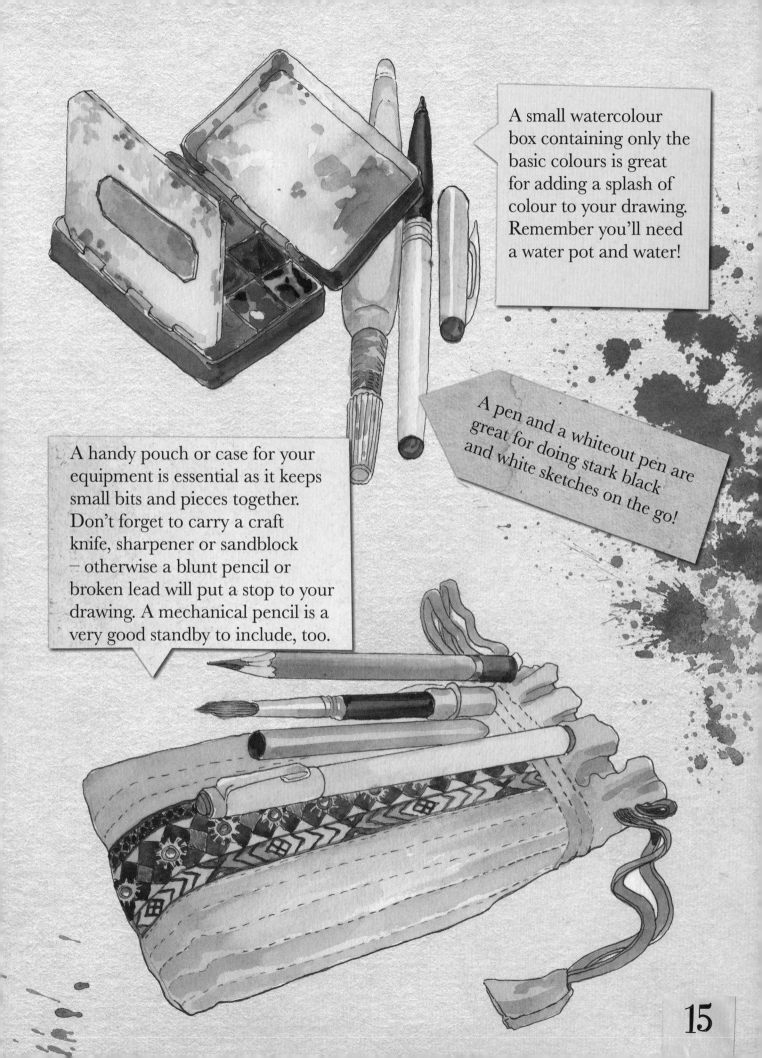

A small watercolour box containing only the basic colours is great for adding a splash of colour to your drawing. Remember you'll need a water pot and water!

A pen and a whiteout pen are great for doing stark black and white sketches on the go!

A handy pouch or case for your equipment is essential as it keeps small bits and pieces together. Don't forget to carry a craft knife, sharpener or sandblock – otherwise a blunt pencil or broken lead will put a stop to your drawing. A mechanical pencil is a very good standby to include, too.

EASELS

There are different types of easels, each to support the type of artwork you want to do and the size you want to make it.

An artist's pochade box has a small compartment for materials and, in some, you can slot a board into the lid. Perfect for small works on the go!

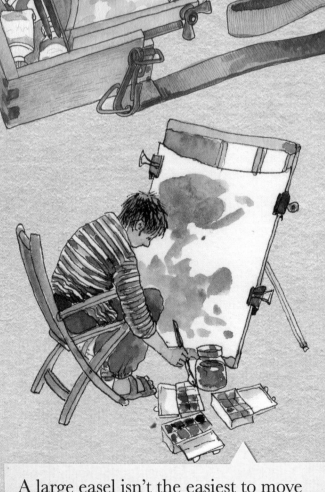

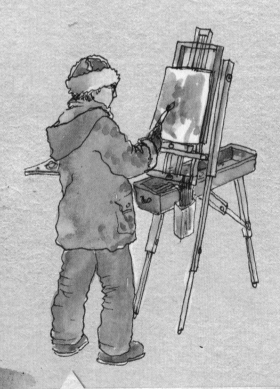

A French box easel has collapsible legs, plus a box in which to store art materials. This is useful for painting landscapes.

A large easel isn't the easiest to move around but is perfect for large scale works. Remember to bring a chair, as paintings can take a while!

CHAPTER 2

MAKING YOUR MARK

There are many ways of making your mark on paper. Each piece of equipment can be used in a variety of ways to create a myriad of different marks.

Some equipment is better for making precise marks for detailed drawing, while other tools are best used for larger, more expressive forms of artwork. It all comes down to experimenting with different materials to find out what suits you, and best meets the requirements of the artwork that you are trying to create.

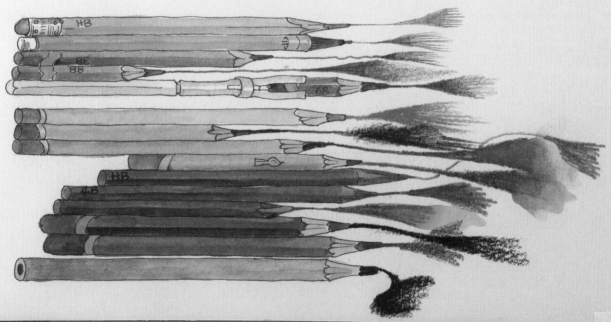

PENCILS

In England, in the mid 16th century, a shiny black substance was found underneath trees felled by a storm. At first the substance was thought to be lead, but it was a type of carbon called graphite. It was used for writing and drawing. It was very brittle so string was wound around it for protection. Later it was inserted into hollowed-out wooden sticks. In 1795, a French chemist called Conté mixed powdered graphite with clay, made it into sticks and hardened them in a kiln. Adjusting the mixture controlled the lightness or darkness of each graphite stick. Pencils range from 9H to 9B.

Graphite stick

Thinner sticks are coated in lacquer. Fat chunky ones are good for big expressive drawings.

Erasers

Flexible white plastic erasers can be cut into a sharp point if needed.

Kneaded eraser

A malleable rubber eraser which lifts marks off the paper and can be shaped for detailed work.

Pencils encased in wood: the clay part of the mixture is the 'hardness' or 'H' factor of a pencil. The graphite part is its 'blackness' or 'B' factor.

6B
3B
HB
5B

Paper stump

For blending and softening pencil marks. Fingers can be greasy but if you don't have a paper stump handy…use them!

ARTIST'S TIP:

Never drop your pencils, or rap them on a table top as the lead inside will break…they will be ruined!

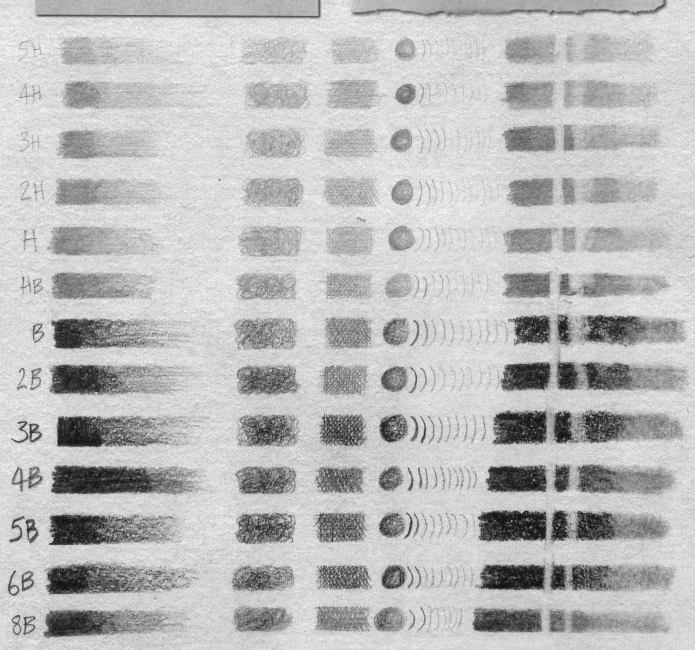

5H
4H
3H
2H
H
HB
B
2B
3B
4B
5B
6B
8B

THE RIGHT PENCIL FOR YOU:

This will depend on your personality…honestly! If you like drawings to be neat and controlled then a harder pencil will suit you better. If you are a bit messy and expressive, then a softer pencil might be your best option. Try them out to find which you like best.

PEN AND INKS

Working with ink can be scary at first as you can't correct mistakes by erasing them. However, inks make very exciting marks that can create wonderful results. It is a great medium to add to your kit.

Whatever inks or pens you use, begin by making a whole series of different lines and patterns to try out your tools. Play around with them to find their potential.

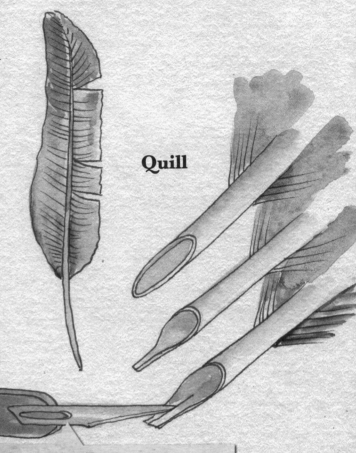

Quill

QUILL: Make your own quill from a feather, and feel like Shakespeare! It will make some very interesting lines.

Bamboo pen

BAMBOO PEN: Makes very interesting marks, but does run out of ink quickly. Van Gogh used one!

BRUSH PEN: A good sketchbook tool! Line width can be altered by increasing pressure.

Brush pen

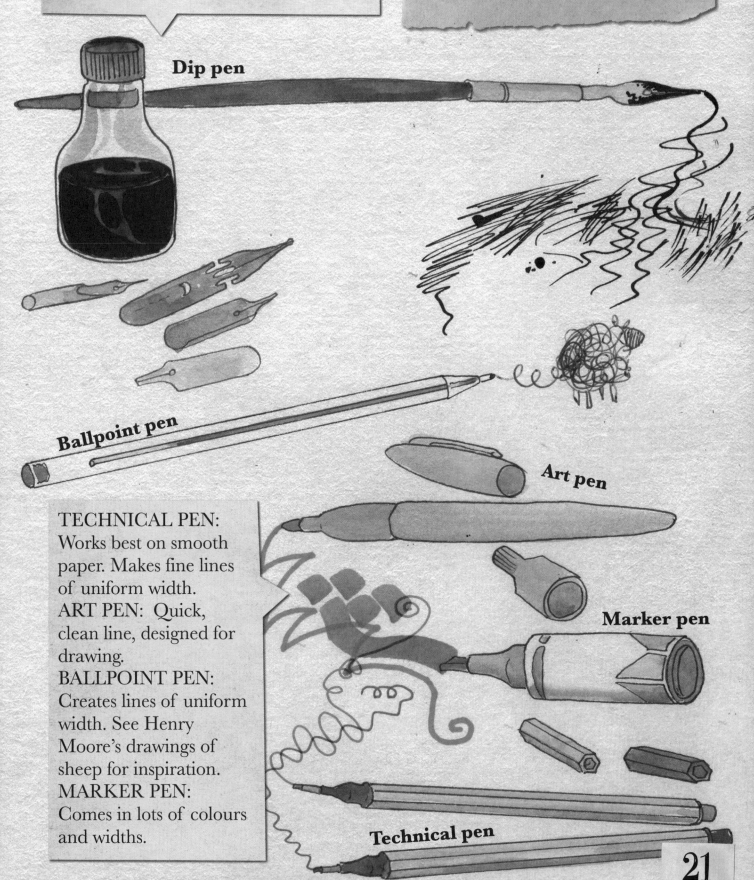

DIP PEN: These traditional pens can hold a variety of different nibs. They create interesting lines and surprising splatters!

ARTIST'S TIP:
Make sure your paper is thick enough or the ink may seep through it.

Dip pen

Ballpoint pen

Art pen

TECHNICAL PEN: Works best on smooth paper. Makes fine lines of uniform width.
ART PEN: Quick, clean line, designed for drawing.
BALLPOINT PEN: Creates lines of uniform width. See Henry Moore's drawings of sheep for inspiration.
MARKER PEN: Comes in lots of colours and widths.

Marker pen

Technical pen

21

CHARCOAL AND PASTELS

Vine charcoal, made from grape vine, is dark grey and harder than willow. Willow charcoal is made from willow branches. It is black, soft and easy to erase. Nitram Charcoal is made from machined wood. It comes in different grades of hardness and can be sharpened to a fine point. It is less messy than willow or vine and makes a strong black mark that can easily be erased. Compressed charcoal is powdered charcoal held together with a binder of gum or wax. It is harder and often blacker than willow and vine. Because of this, it can be sharpened for detailed drawing. All charcoal drawings must be 'fixed'. No amount of fixative, however, will ever make them completely smudge proof. They must be protected with tissue sheets or framed.

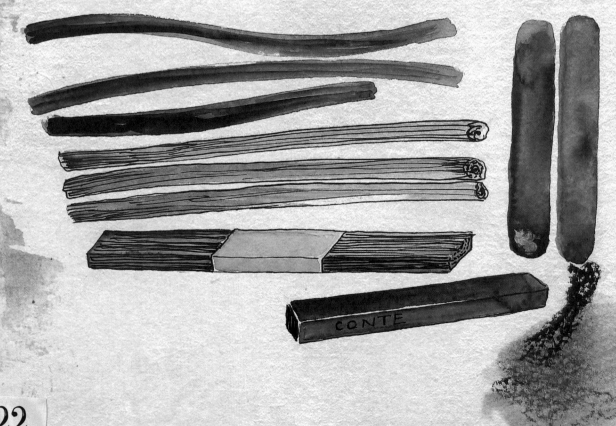

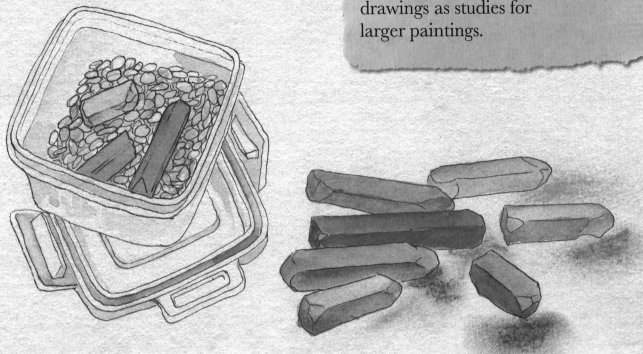

Pastels are pigments mixed with a binder. Chalk was traditionally used as a binder, but other materials are now used. Pastels allow you to layer and blend vibrant colours to create a soft look. It has been a favourite medium of many well-known artists, including Manet, Degas and Renoir. You can buy sets that include dozens of colours but a set of 12 is ideal to start. You can also choose specific colour themes, such as earth tones or shades of grey. If you like the medium, buy more. Soft pastel sticks allow for better blending, while hard sticks are better for details. Working with pastels is like painting with a dry medium.

THE WAY COLOUR WORKS

The history of paint and colour is quite fascinating. There is enough information available and so much to learn about colour that several books could be dedicated to this topic alone.

It is hard not to be overwhelmed by the vast choice of wonderful colours available in most mediums. It can be extremely interesting to look at the 'palette' or colour choices of your favourite artists, and this may well influence the colours you choose to buy. A good way to test out your colours is by painting a small colour wheel.

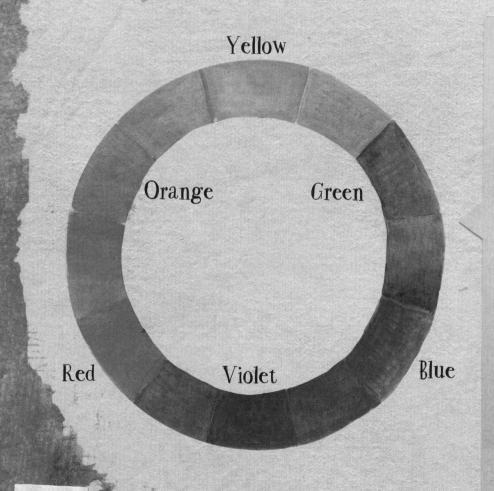

Yellow · Orange · Green · Red · Violet · Blue

Divide a circle into twelve sections. Paint the top part **yellow**. Moving clockwise, miss three spaces and paint the next one **blue**. Repeat this gap and paint the next one **red**. These are the three **primary** colours. All colours are mixed from them. An equal mixture of two primary colours will create a **secondary** colour:
Yellow + Blue = **Green**
Blue + Red = **Violet**
Red + Yellow = **Orange**
The remaining colours are a mixture of the primary and secondary colours adjacent to it on the wheel.

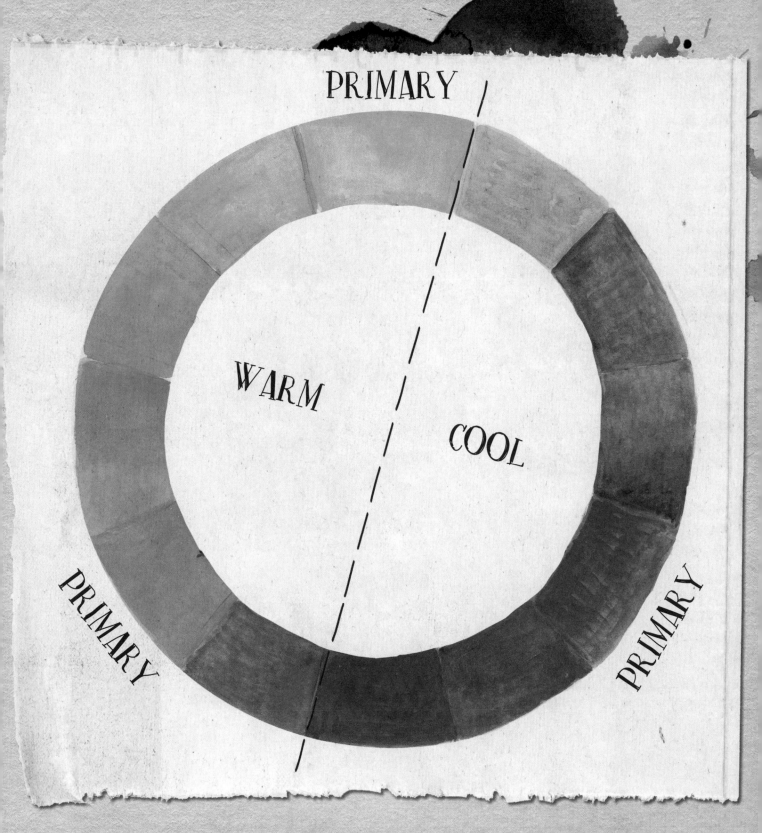

PRIMARY

WARM

COOL

PRIMARY

PRIMARY

Colour is also thought of in terms of its warmth or coolness. If you draw a diagonal line through your colour wheel the warm colours are on the left side and the cool colours are on the right.

Warm, energetic colours seem to move forward and appear larger. Cool colours are calmer. They seem to move back and appear smaller. Artists use this aspect of colour to convey distance and mood in a painting.

Mixing colours is the way to create all the varied tones you will need when painting. Experiment with mixing, but be careful not to add too much of one colour to another in one go or it will dominate. Also, if you mix too many colours together you will invariably end up with a muddy brown!

Watercolour sticks

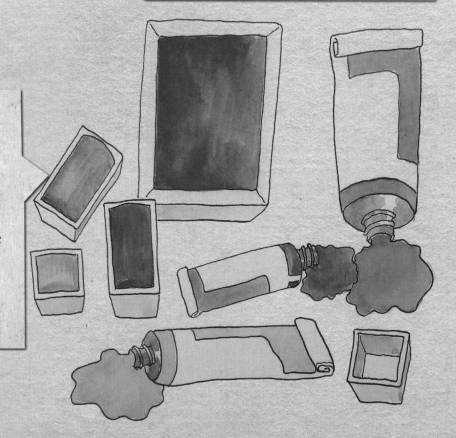

Different paints

Different types of paint can influence the way colour mixes. However, the same principles of mixing generally still apply even if you are working with diluted washes.

Colour mixing guide:

This grid shows the results of each individual colour (top row) being mixed together with each successive colour in the left-hand column.

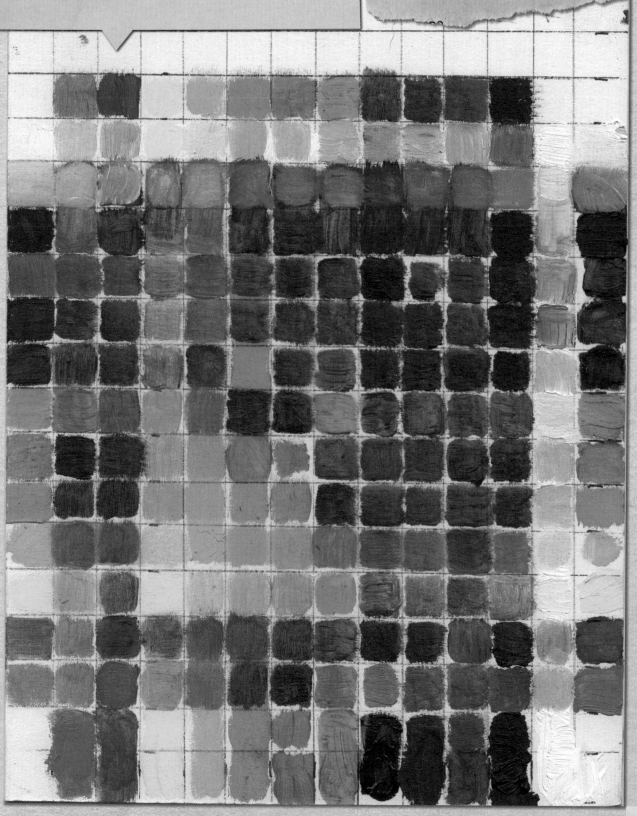

BRUSHES

Paintbrushes range in size, shape and structure. Each can make a different mark or create a different effect depending on the paint or technique that is used.

Softer brushes are good for thinner, more fluid paints, such as watercolours, and stiffer brushes are good for thicker paints like oils or acrylics.

It is best to experiment with different types of brushes to find out what suits you best and works well with the style of painting you are trying to achieve.

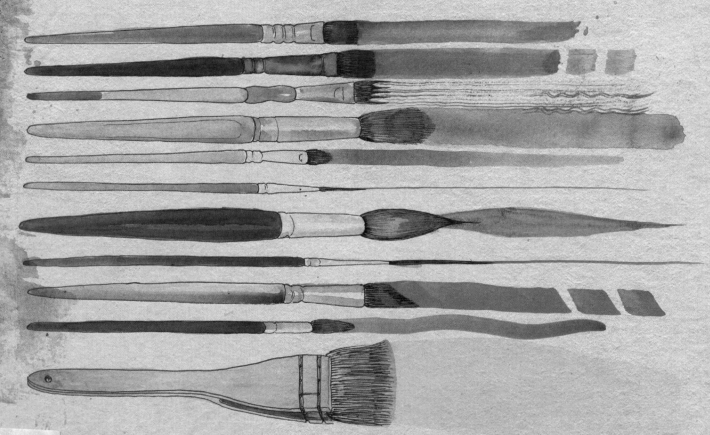

CHAPTER 3

MAKING SKETCHBOOKS

Carrying a sketchbook allows you to practise your drawing skills at any time and becomes your own personal training programme. It is a vital accessory for all artists! A sketchbook is like a visual diary that reflects a very personal insight into your thoughts and your response to the world around you. The contents can be completely private or shared, as you prefer.

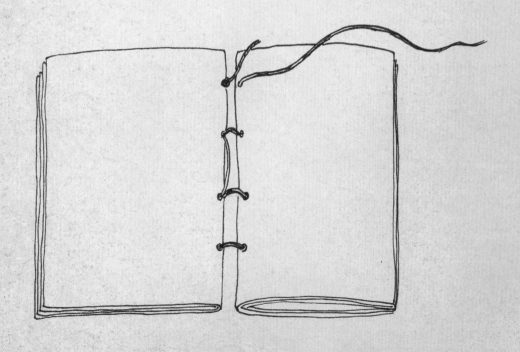

The most important thing about making a sketchbook is that it is 'yours' – use any kind of paper that you want, you can even use a cereal packet to cover it! Once it's finished, just enjoy glorified doodling. Expensive sketchbooks can be very intimidating, whereas a handmade one should be more liberating – so get started! Playing is how we learn best. Just mess about: try out your pencils, make as many marks as you can with pens and brushes, and test out the colours of your watercolour box…experiment!

Equipment:

- Awl (pointed metal tool)
- Sheets of paper
- Card for cover
- Linen strip
- Darning needle and strong thread
- Glue
- Craft knife

One sheet of A1 paper will make an A6 sketchbook with 64 pages.

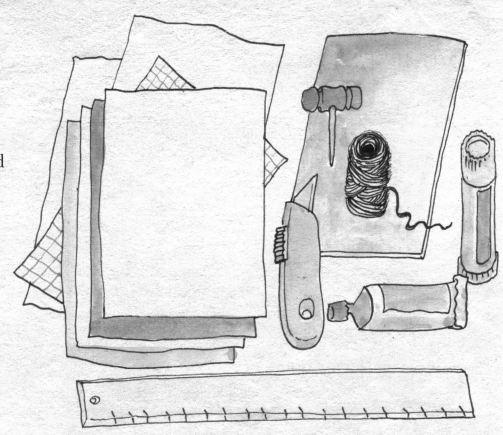

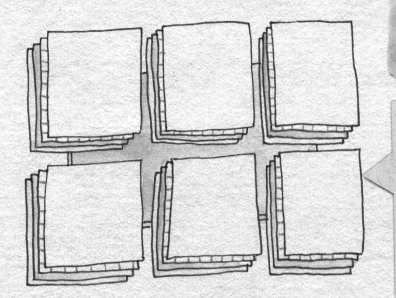

Decide what size you want your sketchbook to be when opened. Cut your paper to this size and separate it into piles of five pages. These will make up the sections for your book.

The size of each sheet of paper represents two pages of your sketchbook, so fold each section in half. Press down firmly on the folded edge.

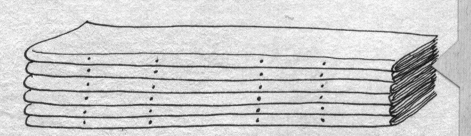

Stack the sections together and hold them tightly. Now mark dots on the spines as shown…**this is important**.

Continued overleaf...

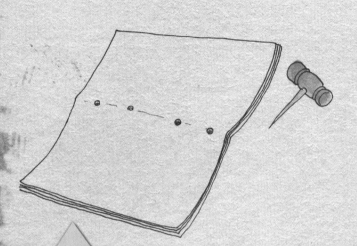

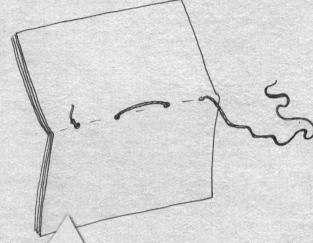

Open out each section (one at a time). Use the awl to make holes through each section where the dots are marked.

Tie a knot in the thread and use a large darning needle to sew the first section together, as shown.

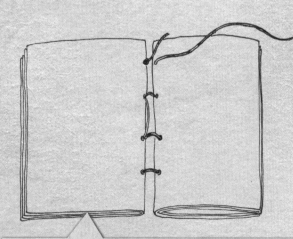

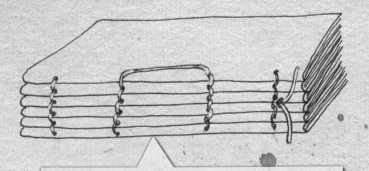

Now take the second section and line up the holes. Sew from the outside through the first hole that lines up. Then sew back through the next hole and into the first section and carry on until the thread comes out at the top.

Pull the thread as tight as you can before tying it to the top knot. Add each section in the same way. When complete there should be a line of thread down the middle, as shown.

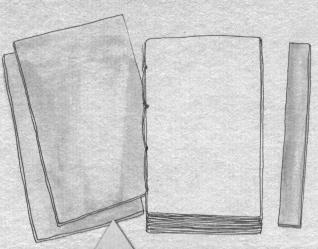

ARTIST'S TIP:
Take time to follow through each step-by-step instruction. Next time around it will be easy.

Cut two covers, the same width as the pages but slightly taller. Cut the spine to the same length and match the width to the sewn edges. At this stage you can cut the pages neatly with the knife if they are a bit messy.

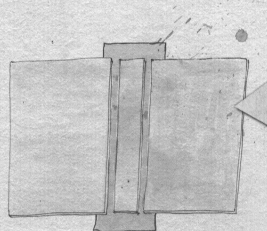

Cut two more bits of paper for the inside covers. These should be the same size as the folded sections. Place the cover and spine on the linen tape, and leave little gaps in between, as shown.

Glue the cover papers inside the sketchbook, front and back. Stick down on the inside cover and the page opposite to complete.

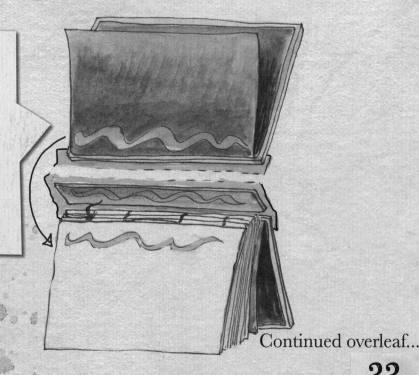

Continued overleaf...

Put some heavy books on top while the glue dries.

Neaten and strengthen the spine with another strip of tape or material…job done!

CHAPTER 4

LIGHT, SHADE, COMPOSITION

Tone is created by the way light falls on a 3D object. Highlights are where the tone is lightest and the light is strongest. The areas which are darkest are shadows. It is this range of tones from light to dark that can help make an object look three dimensional.

Adding tone to a drawing helps to create the illusion of form on a 2D surface. The directional line of the marks you make can also help to emphasise the form of an object. Dramatic artwork can be created by the use of strong contrasts between the lightest and darkest tones.

Texture expresses the surface quality of an object and gives an indication of how it would feel. Drawings can have different kinds of texture: a visual texture is when the feel of the surface has been created by the use of the medium, whereas actual texture is where the medium itself has texture or has been used to create a physical texture.

NEGATIVE SPACE

Negative space is the 'empty' space around the subject you are drawing. It is equally important for defining the shape of your subject. Check the negative space as you draw – if it looks wrong, then the drawing will be wrong too. In this drawing exercise we will start with the negative space.

Materials:

- Blue pastel paper
- Conté pastels
- Dip pen
- Black ink

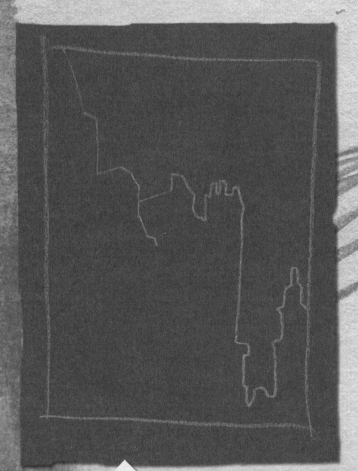

Using a white pastel, sketch out a rough rectangular frame. Then mark out the skyline of the rooftops.

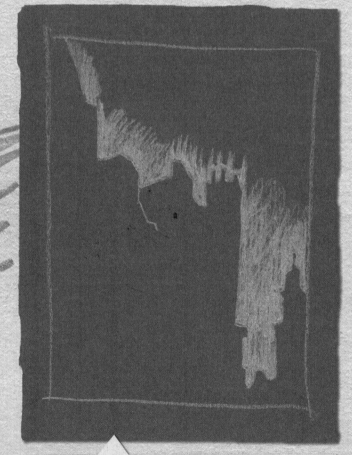

Start to block in the white of the sky, or negative space.

ARTIST'S TIP:

Be confident! An ink line in the wrong place is not a disaster – it's part of the journey. These lines are often lost in the end result.

Fill in the rest of the sky, blending in the white pastel marks as you go.

Use an ink pen to draw in the building details and add a touch of pink pastel to the sky.

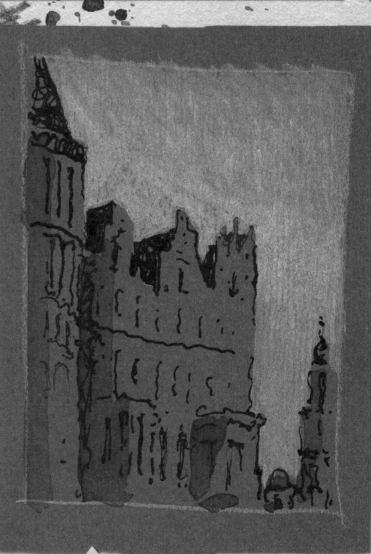

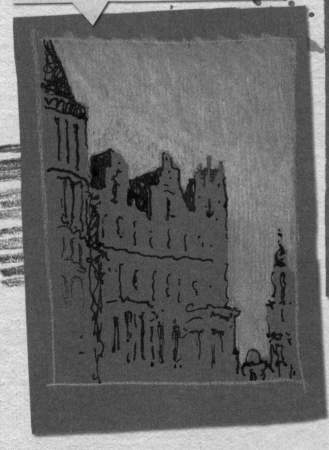

Finally, use a light ink wash to add shadows to the buildings.

STATUE OF EROS

The Shaftsbury Memorial Fountain at Piccadilly Circus, London, is commonly known as the statue of Eros.

Materials:

- Thick blue pastel paper
- White conté crayon
- Gouache: white, blue and yellow ochre
- Black ink
- Dip pen

Identify the negative space made by the buildings and statue (marked red in the photograph).

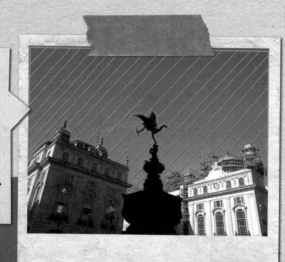

Use the conté crayon to draw the outline of the buildings and statue against the sky. Don't worry about getting every turret and twiddle in the correct place. Concentrate on the main shapes and the angle of your lines.

Mix the white gouache with water into a thin creamy consistency and paint in the sky area. Let it dry. Then mix a little blue into the remaining white paint and paint over the sky area again. Don't worry about how smooth it looks – it really won't matter.

ARTIST'S TIP:

Use thicker pastel paper. Thin paper will buckle when you apply the water-based gouache.

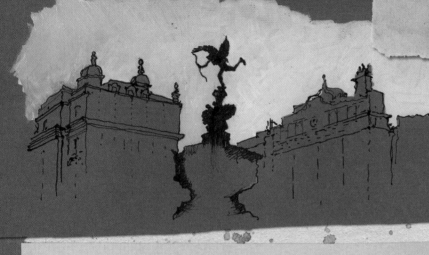

Start inking in the buildings and statue. Make little marks to place the windows and architectural features. Wobbly lines are fine – they will add interest to your drawing. Fill in the silhouette of the statue of Eros.

Add a touch of yellow ochre to the white gouache and mix to a creamy consistency. This pale yellow will create the warm colour of stone bathed in sunlight. Paint in the areas of the buildings that face the sun.

Finish off by adding a few little dots to some of the window panes to suggest light reflecting off the glass. Add a vapour trail in the sky with two brushstrokes of white gouache.

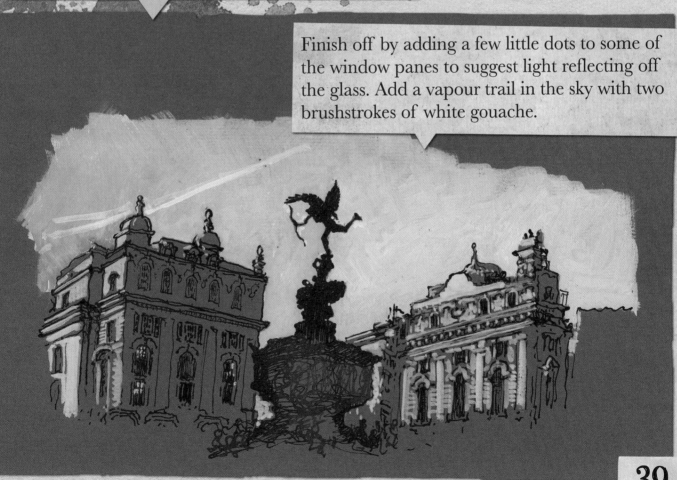

CHARCOAL DRAWING PART 1

This could be Rotterdam, Rheims or Rome, but with the lovely misty Sacré-Coeur in the distance…it must be Paris. Paris rooftops – a clutter of chimneys, windows and pipes. Here we go…

Materials:

- Grey card
- Willow charcoal
- Charcoal pencil
- Compressed charcoal
- Plastic eraser
- Spray fixative
- White chalk pencil
- White gel pen
- Terracotta conté crayon

Try keeping all your drawing materials together in a tin!

Lightly draw out the roof shapes and chimneys with willow charcoal. Add shading to the very darkest areas. Willow is easy to erase so you can make changes at this stage, although no one is going to count chimney pots here!

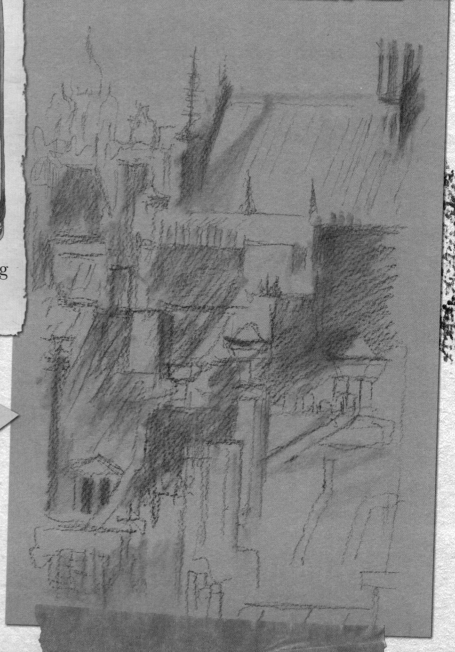

Block in the darkest areas with compressed charcoal. Draw in more detail and use the plastic eraser to create some highlights. Spray lightly with fixative or hair spray once you are happy with this stage. Let it dry.

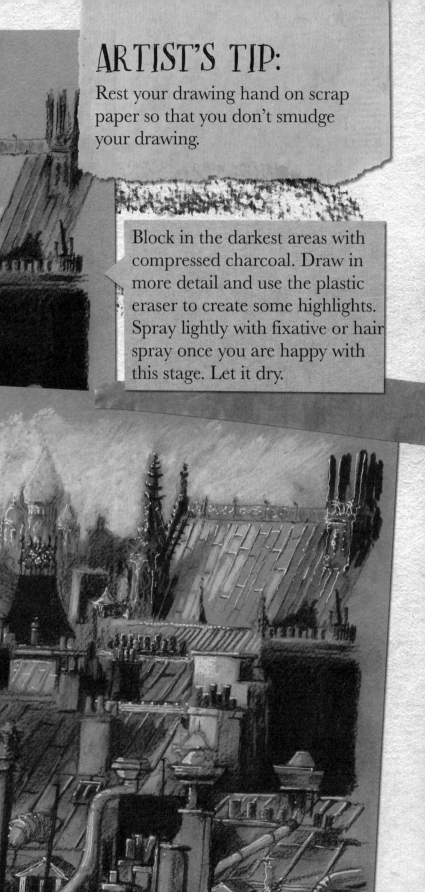

Build up the darks with the conté crayon. Use the white chalk pencil to heighten the highlights and to block in the sky. Lightly fix again and allow to dry.

Continued overleaf...

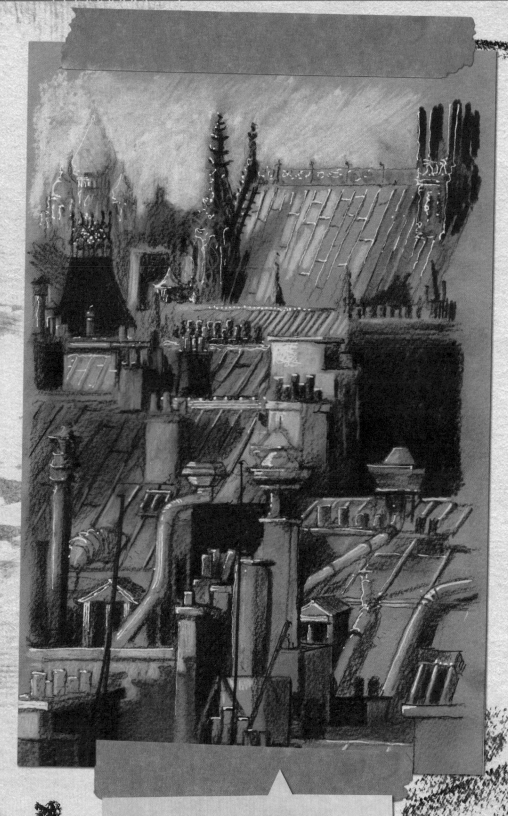

Use the white gel pen to pick out little dots and lines for the whitest highlights. Don't overdo it!

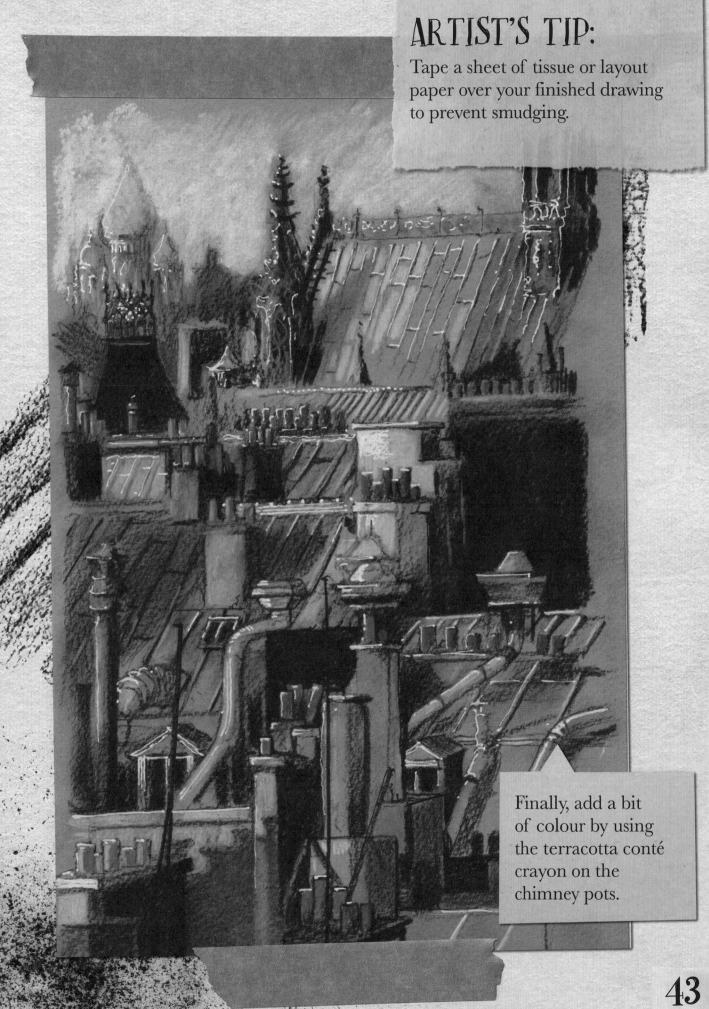

ARTIST'S TIP:

Tape a sheet of tissue or layout paper over your finished drawing to prevent smudging.

Finally, add a bit of colour by using the terracotta conté crayon on the chimney pots.

Cities often have busy farmers' markets. This market is in the park near Alexandra Palace in London. The awnings on the stalls make great patterns, colours and textures. On a sunny day the deep shadows add even more interest to the scene.

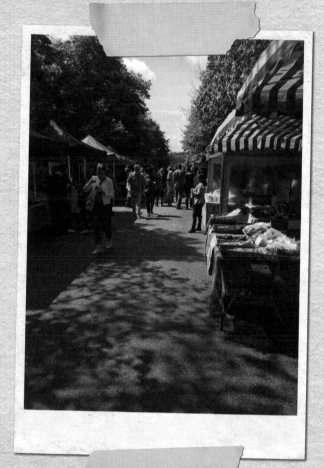

Materials:

- Dip pen
- Sepia drawing ink
- Smooth, hot pressed paper (300gsm)

We'll use a photograph of the farmers' market as the starting point for this sketch. Note how the shadows extend under the awnings of the stalls and how the vanishing point is in the centre of the image.

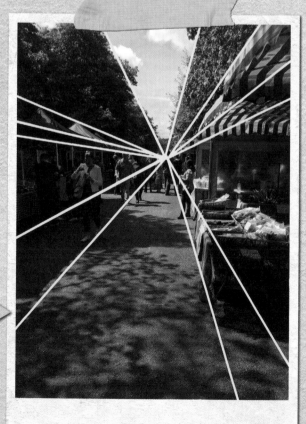

ARTIST'S TIP:

It's okay to use photographs – it's not cheating. It is especially helpful when you are learning to draw and paint.

Lightly mark out the position of the main shapes with little dashes and lines. Note the perspective on the market stalls.

Add more patterns to the awnings.

Start to add more detail to the shape of the trees. Build up the leaf shapes using a variety of marks and lines. The leaves on the trees nearest to you should be larger and will get smaller as they recede.

Continued overleaf...

Don't overwork the trees. The densest areas of foliage should still allow the paper to show through. Now start to add shading under the awnings, using broken vertical lines. Note how the woman, mid composition, has been depicted very simply using short curved lines only.

Use lots of little dashes and curved lines to fill in the darker shadowy areas. Notice that nothing has a solid outline. Patterns and textures are creating the shapes.

Extend the shadows across the people in the left-hand foreground and add their shadows on the ground. Draw in the stripes on the awnings.

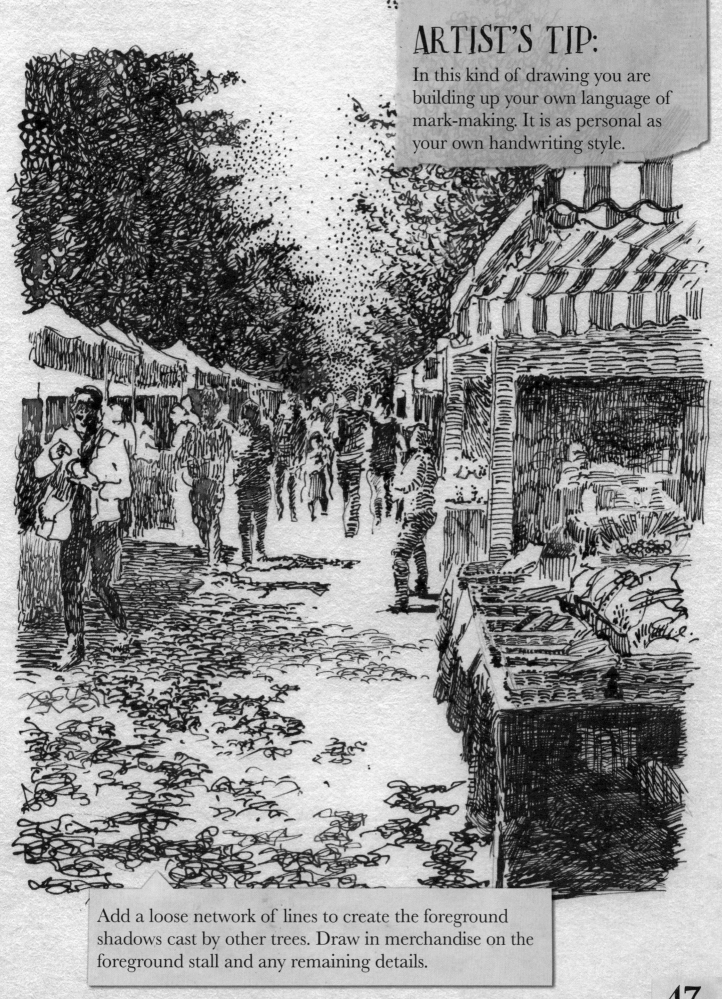

ARTIST'S TIP:

In this kind of drawing you are building up your own language of mark-making. It is as personal as your own handwriting style.

Add a loose network of lines to create the foreground shadows cast by other trees. Draw in merchandise on the foreground stall and any remaining details.

TEXTURE

These beautiful buildings in London were built in the 1890s. They were designed to "suit the requirements of bachelor artists". I have loved them ever since I first set eyes on them. With their wealth of architectural detail they make a fabulous subject to draw.

Materials:

- Smooth paper
- Black Indian ink
- Dip pen
- Paintbrush

Begin anywhere. I started at the very top with the turret and large window. I tend to draw with a slightly shaky line, making dots and dashes until I find the correct placing for the lines.

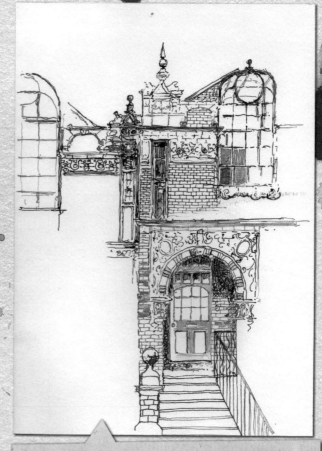

Continue drawing, adding squiggles for the carving, and crosshatching for the darkest bits. The bricks and tiles create interesting patterns and textures. I dip my pen into water if I want areas of paler ink.

ARTIST'S TIP:

Look more at your subject...and less at your paper!

Draw in the railings and additional brickwork. I have darkened some of the bricks with an ink wash using a wet brush dipped into diluted ink.

Finish off with more diluted ink washes. I have drawn into some of these washes once they are dry – like the window panes on the front door. Applying simple washes without an ink outline softens the outer edges of the drawing on both sides.

COURTYARD PART 1

This courtyard is in the narrow streets of a little town in Provence, France. It was lunchtime, so the perfect time for a little 'plein air' painting as everyone is either eating lunch or asleep!

Use brushstrokes to draw in the main shapes and features, using a mix of burnt sienna and ultramarine diluted with turpentine. Concentrate on proportions and angles.

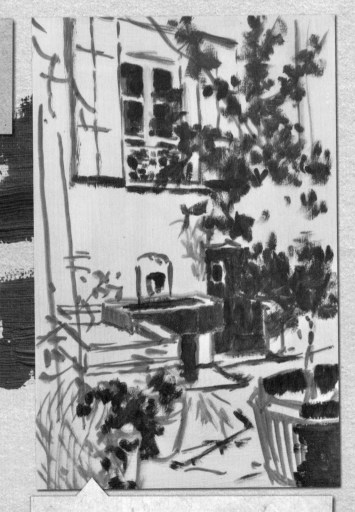

Half close your eyes and roughly paint in the darkest 'darks'. This will help to establish tones in the painting.

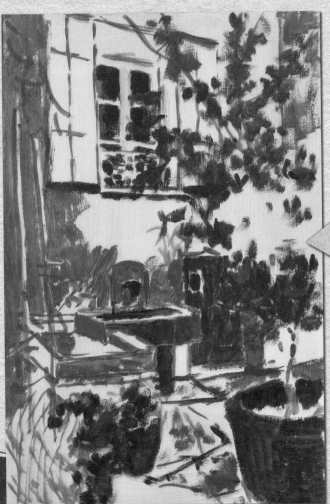

ARTIST'S TIP:
A muddy palette creates muddy colours – refresh it!

Block in the colour of the walls and trough using a mixture of yellow ochre and burnt sienna. The wall colour will eventually be lightened, but this darker base will create a better texture.

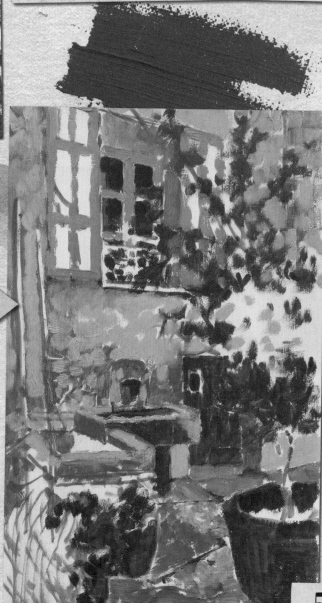

Dab Naples yellow over the walls and into the tree. A spot of Paynes grey and white added to the Naples yellow makes a soft, warm grey for the shutters.

Continued overleaf...

51

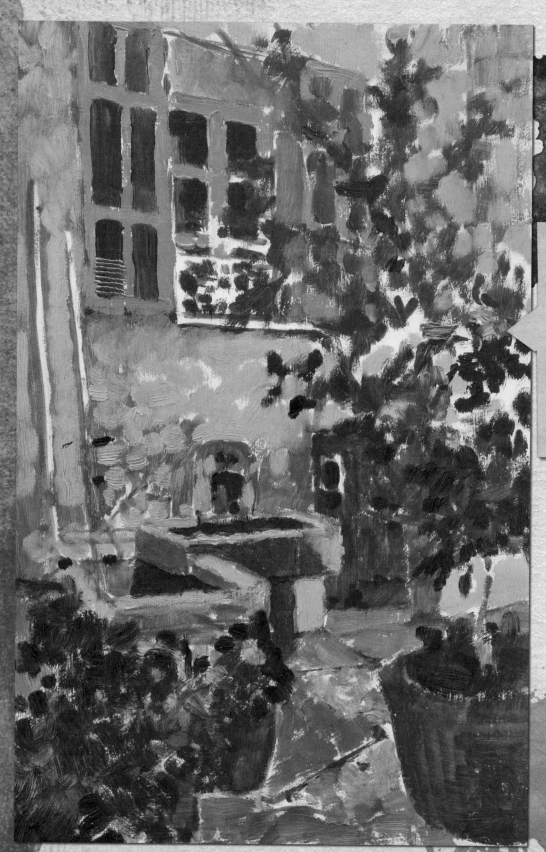

Adding white to the wet paint on the wall creates more texture. A sweep of light creates a highlight along the edges of the troughs.

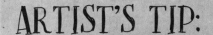

ARTIST'S TIP:

Tape cellophane to your palette. Easy to scrunch up and dispose of leftover oil paint at the end of the day!

Add blocks of a muted grey colour to the shutters, and scratch lines into the wet paint with a toothpick. Paint the plants and the tree in a dark green and lightly dab a paler green over it. Use lemon yellow and ultramarine to make all the shades of green. Note the reflection of the wall and the shadows in the water of the large trough.

Continued overleaf...

COURTYARD PART 3

Add more lighter coloured leaves to the plants. Scratch through the wet paint with a sharp pencil to make dark lines and use a toothpick (or scalpel) to make light lines. Finish off with the last remaining details.

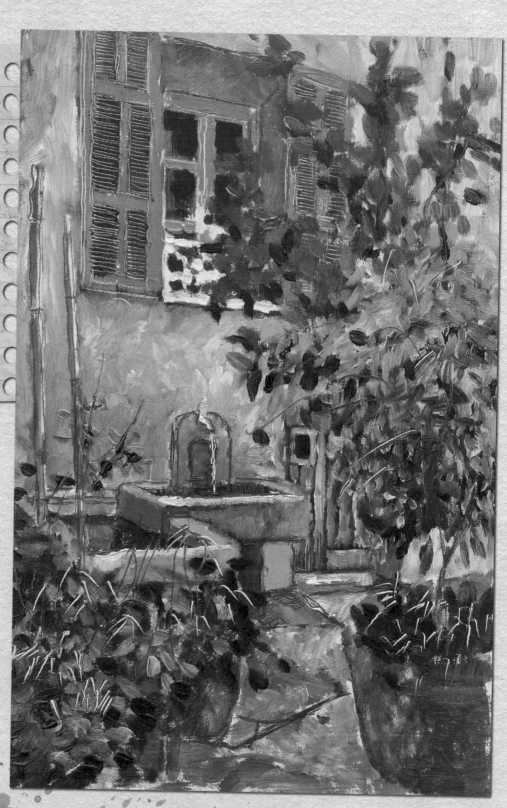

CHAPTER 5

HOW LONG DO YOU HAVE?

How you approach a subject can depend entirely on how much time you have to spend on artwork. You may only have ten minutes or perhaps three hours, yet both results can be equally as exciting.

A quick drawing done in an expressive style can often successfully capture the energy and vibrancy of a scene. With practice you will start to recognise the most important elements to capture.

When you have more time, you can study a scene carefully to consider how best to make marks that will capture the elements of your composition. You also have time to work on smaller details.

Ten minutes is quite a long time! Concentration and careful observation will help you grasp the essential information needed to draw even quite a complicated scene. The perspective lines of this indoor market provide the starting point for this drawing.

Materials:

- Tinted pastel paper
- Pastel pencils (or chalky pastels): yellow ochre, Naples yellow, light pink, light blue, dark brown, dark blue, and black.

Lightly sketch in the perspective lines.

ARTIST'S TIP:

Chalk pastels are easily broken and need to be handled with care.

Draw in the sunlit upper wall using vertical yellow lines and also lines following the perspective of the floor. Add small vertical lines to indicate highlights in other parts of the composition.

Draw in the glass roof using the pale pink and pale blue pencils. Add a touch of Naples yellow to the upper walls to indicate windows. Start to draw in some of the signs.

Continued overleaf...

Concentrate on the bare essentials of shape rather than detail. Tables and chairs are 'suggested' simply with a few vertical and horizontal lines.

Note how little dashes of light become a visual prompt for your eye to decipher the understated elements of the scene and tell you what you are looking at. The figure is simply a dark squiggle at the far end, but it gives a clue to scale and distance.

ARTIST'S TIP:

In this type of sketchy drawing, you can choose to 'lose' aspects that don't appeal. It's your drawing – you are the boss!

Add a few lines with a sharp black pastel pencil to complete the sketch.

Drawing architectural scenes is always interesting. The details often look too complicated but just take it steady. Follow your eye around the subject and don't worry too much about straight lines!

Materials:

- Stretched Canvas 50 x 50 cm
- Charcoal pencils
- Selection of medium sized filbert hog hair brushes
- Oil paint: burnt sienna, french ultramarine, Phthalo green, sap green, olive green, windsor lemon, yellow ochre, Naples yellow, Davy's grey, alizarin crimson, titanium white
- Turpentine

Loosely draw in the main shapes.

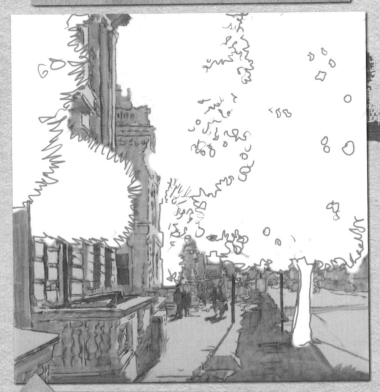

Use a wash of very diluted burnt sienna, mixed with turpentine, to indicate the tonal values.

ARTIST'S TIP:

Keep the drawn line to a minimum so you concentrate on shapes and colour rather than detail.

Block in the shapes of the big trees using ultramarine and some Phthalo green. I like to let colours mix on the canvas.

Add more dark greens to the trees. Then make a 'black' – mix alizarin crimson, ultramarine and olive green. Start to block in more of the dark areas.

Use Naples yellow for the sunlit stone facades of the buildings, and yellow ochre for areas where light does not reach.

Continued overleaf...

61

Naples yellow, titanium white and a touch of ultramarine make a good grey for areas of cool shadows. Start adding some yellow light to the trees to show their form. Use Davy's grey for the distant background including the tree.

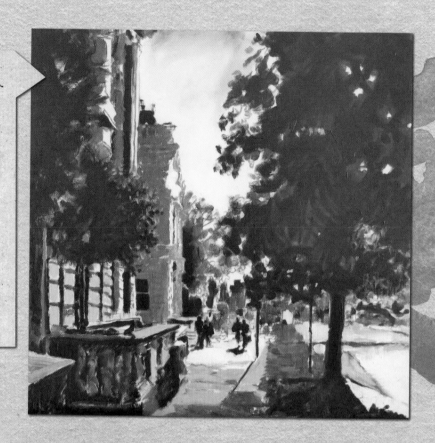

Paint in the sky with titanium white – remember the area behind the branches of the tree. Add touches of white to emphasise the light on the buildings and pavement. Dab some white onto the background and more yellow greens onto the trees in the foreground.

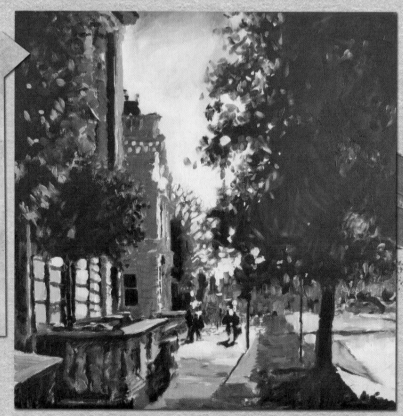

Photographing a scene can be helpful. If you turn the photo and your canvas upside down, you start to get a clearer picture of your composition in pure abstract shapes.

Scratch the end of your paintbrush through the wet paint to create some fine lines to suggest paving slabs in the foreground.

Sometimes it's impossible to just stop, sit down and sketch. When something catches your eye and shouts out to be painted – take a snap. You can then get the photo up on your screen and work on it at your leisure. The fact that the image is small can be an advantage, as it is much easier to see the main shapes and tonal differences.

Materials:

- Heavyweight watercolour paper (approx. 2.65 gsm)
- Selection of watercolour brushes
- Watercolour paints
- Light green chalk pastel
- Fine marker pen (dark green)
- Like most artists, I have found the colours, brushes and papers that suit me best. This aspect is highly personal – so experiment.

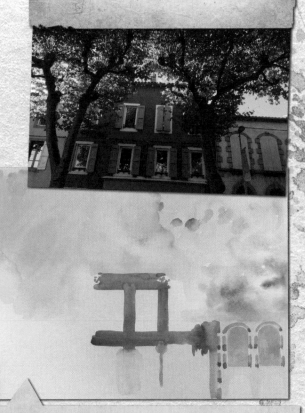

Paint the background 'wet on wet': wet the paper then add washes of lemon yellow with a touch of cerulean blue.

Let the wash dry, then add boldly coloured walls. See how colours change as they merge and run into each other.

When painting in watercolour, start with the lighter tones and washes. Then layer your paints towards the darker colours.

Now add contrasting colours for the shutters.

Once dry, add more detail to the shutters. Note the dark green reflections in the windows. Paint in the ridge of roof tiles.

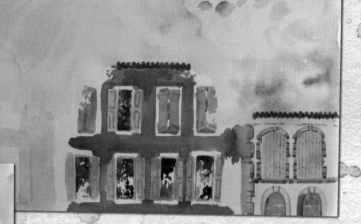

Start painting in the tree trunks. Remember – lightest colours first!

Begin to add foliage using a variety of light greens. Use single brush marks to suggest leaf shapes.

Continued overleaf...

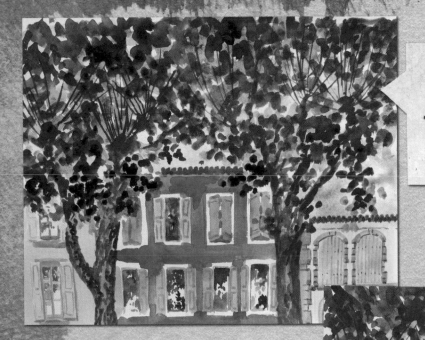

Gradually darken the foliage and tree trunks, and add twig-shaped branches.

I have used 'artistic licence' to add a tracery of blue shadows across the buildings. I felt this would add an interesting touch to the red walls.

Finish by adding the darkest tones to the foliage and a few lines to emphasise some building details. I also used some light green pastel marks to create some highlights.

CHAPTER 6

CREATIVE RISKS

Taking creative risks with your approach to artwork can open up new styles and ideas for you whilst still improving your overall skills. Sketchbooks don't have to be filled with 'perfect drawings'. Try some experimental exercises that may help you to 'see' in new ways by taking you out of your comfort zone.

You can try to break free of making predictable marks by forcing yourself not to look at the paper while you draw, only at your subject. Or, try not lifting your pen or pencil off the paper at all whilst completing your sketch. Perhaps you could even cover your paper in graphite and erase parts of the image to create a negative.

Experiment and take creative risks to develop your range of marks and observational skills.

BLIND CONTOUR DRAWING

Blind contour drawing is a great practice exercise. It tones up your observation, builds your confidence and makes your drawing more fluid and expressive. Honestly! The point of this exercise is the process, not the end result!

Materials:
- Paper
- 3B Pencil

You will be drawing 'blind', in a single continuous pencil line. Firstly, you do not take your eyes off your subject as you draw and once you put pencil to paper – you don't lift it off again. If you can't trust yourself not to check your drawing, then obscure your view of it!

The line will keep changing direction: down and along the doorstep, around the steps and up the other side.

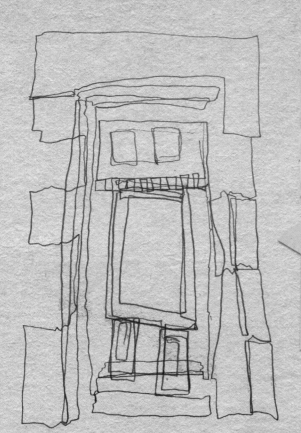

ARTIST'S TIP:

Imagine that the pencil is your 'eye'. As you move your eye around your subject, move your pencil around each step, each stone, too.

As your pencil line follows the stonework around the door, it does so in a continuous line that constantly changes direction.

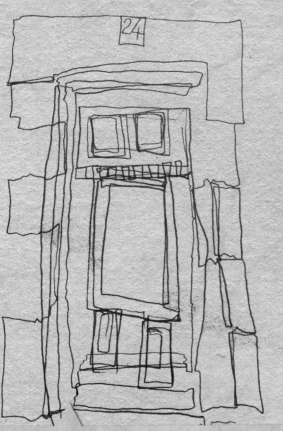

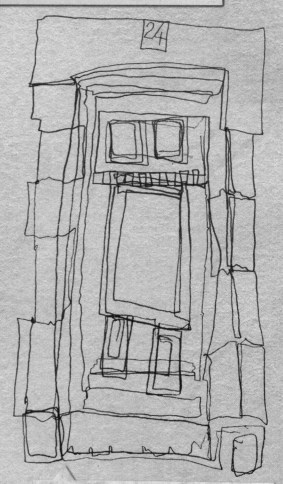

You will be surprised to find that most of what you have drawn is in the right place. However, as I said, this is not important. This exercise is purely about 'honing' your eye.

The end result will be wobbly but notice how well observed some of the details are. Blind contour drawing helps you to recognise what you find important in your subject.

MESS IT UP! PART 1

A new white page in a sketchbook can be very daunting. All that pristine space just makes us worry about making mistakes. A good trick is to mess the page up a bit first. Add a wash of paint or just scribble on it. This makes it less precious and frees you up to enjoy yourself.

This line drawing is a small section of architectural detail from Alexandra Palace in London. The building is a complicated subject: all brick work, carvings and a glorious window. Don't panic…

Materials:
- Paper
- Dip pen
- Indian ink

It doesn't matter where you start. This is your drawing – build it brick by brick. Keep calm and begin…

Break down complex shapes in your mind. Look at each bit to see how it is made, then draw it line by line. Remember, this is your drawing – do not be intimidated by the subject or the outcome.

ARTIST'S TIP:

Don't worry if your ink line wobbles or wavers off-course. This just adds interest – you're not doing a technical drawing!

Extend your drawing as far as your paper allows.

Draw in horizontal lines for the bricks. I plan to draw in marks for each brick, a bit intense perhaps but that is what I want to do.

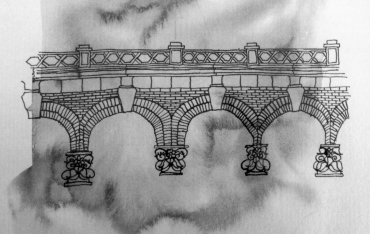

Remember that bricks are laid in a staggered pattern. Draw yours the same way.

I started drawing the circle in the middle of the window first, then worked outwards, adding detail.

Continued overleaf...

71

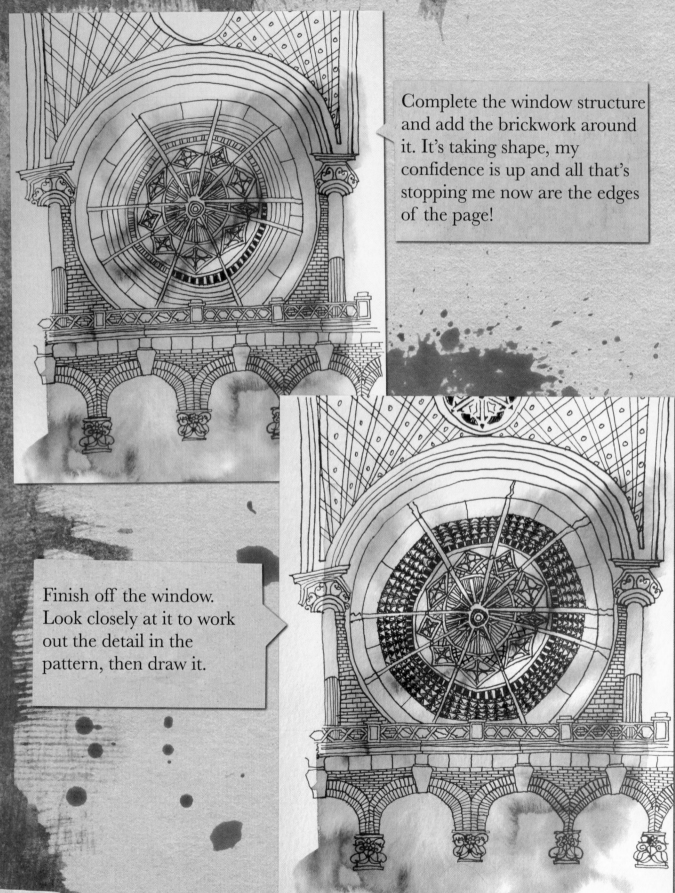

Complete the window structure and add the brickwork around it. It's taking shape, my confidence is up and all that's stopping me now are the edges of the page!

Finish off the window. Look closely at it to work out the detail in the pattern, then draw it.

ARTIST'S TIP:

Don't allow unexpected splodges from your dip pen to stop you in your tracks. Just ignore small accidents and keep drawing!

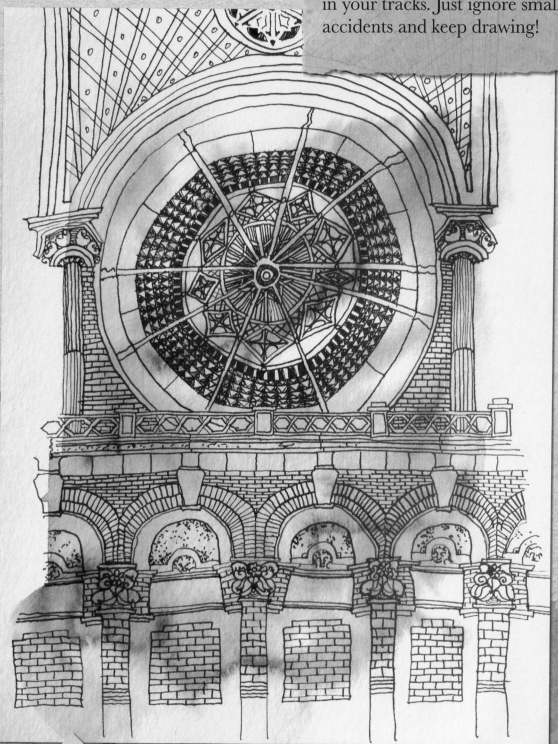

Complete the rest of the drawing in the same manner and you will end up with a nicely detailed, lively drawing of quite complicated architectural details.

WRONG HAND

Another useful exercise is to draw with your non-dominant hand. So if you're right-handed, draw with your left hand, or vice versa. Work quite fast, forget about making a neat and perfect drawing. Just look and draw and don't worry about the end result!

Materials:
- Paper
- Conté pencil

Put your dominant hand behind your back...or sit on it. Have a good look at your subject first, then begin to draw.

You will quickly notice how difficult it is to draw straight lines, but don't worry, just carry on. Concentrate mainly on angles as you would normally.

You may find that you are drawing on a larger scale than usual.

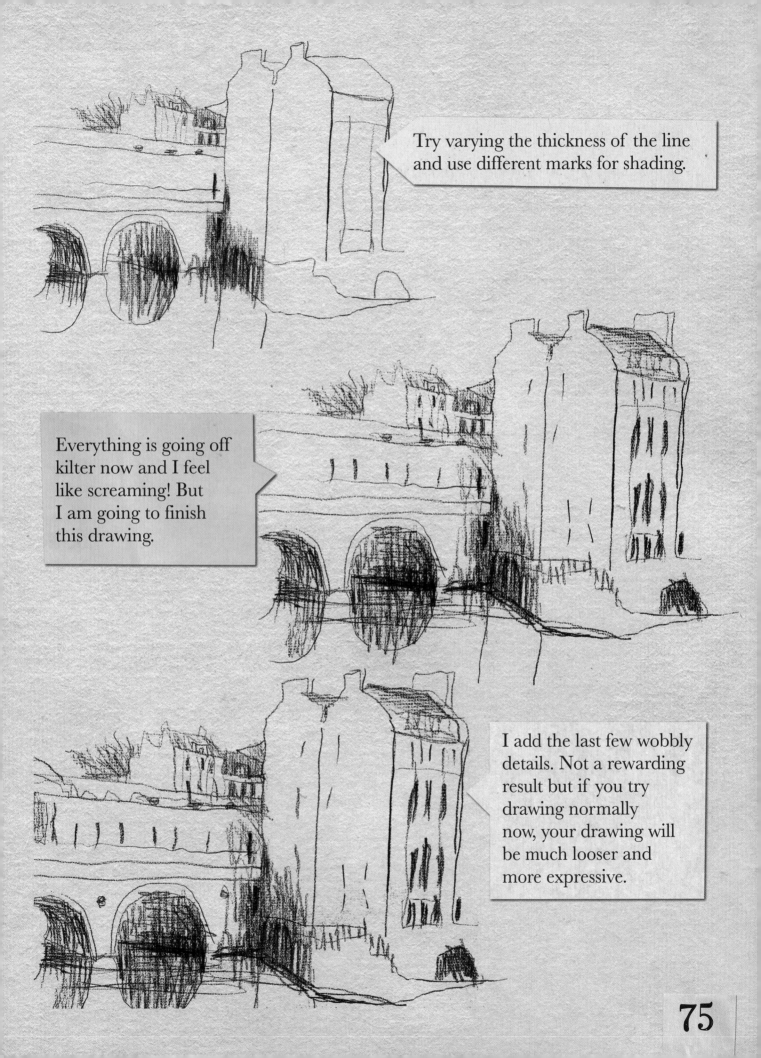

Try varying the thickness of the line and use different marks for shading.

Everything is going off kilter now and I feel like screaming! But I am going to finish this drawing.

I add the last few wobbly details. Not a rewarding result but if you try drawing normally now, your drawing will be much looser and more expressive.

ERASURE: PART 1

This exercise helps you to loosen up by making you see your drawing purely in light and dark tonal shapes. It's a process of 'drawing' with light. It's the perfect way to capture all the lights and reflections of a rainy cityscape at night.

Materials:
- Paper
- Plastic eraser
- Kneadable eraser
- Pencil
- Charcoal
- Conté crayon

Completely cover your paper with pencil shading. Don't be tempted to smudge it in with your fingers.

Look carefully at your subject, then start 'drawing' with the eraser. Lift off areas of light.

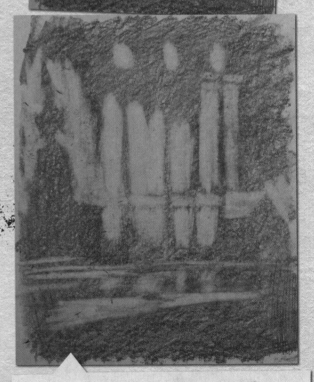

Pick out larger shapes first, but look for areas of light reflecting on surfaces, too.

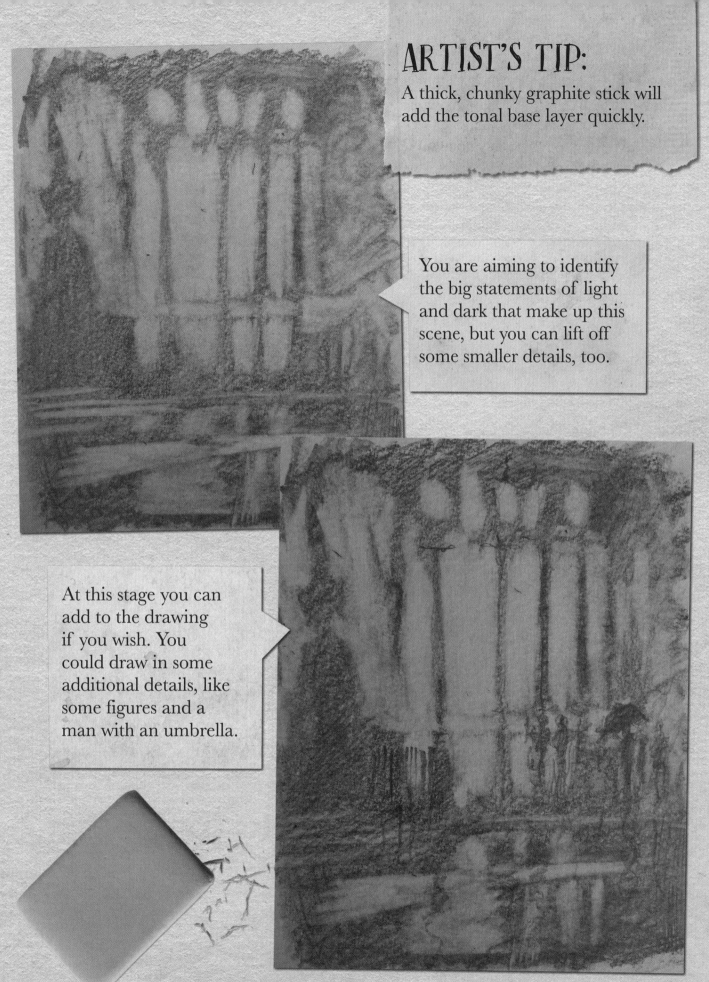

ARTIST'S TIP:
A thick, chunky graphite stick will add the tonal base layer quickly.

You are aiming to identify the big statements of light and dark that make up this scene, but you can lift off some smaller details, too.

At this stage you can add to the drawing if you wish. You could draw in some additional details, like some figures and a man with an umbrella.

Continued overleaf...

ERASURE: PART 2

This is a continuation of the same exercise but using conté crayon and charcoal instead. Erase light areas in the same way.

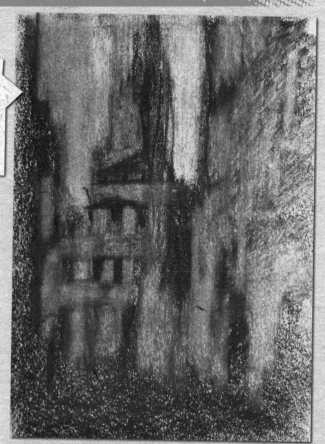

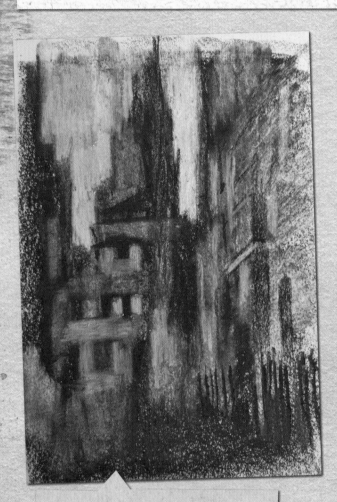

Draw in lines to indicate perspective and to add some details like fencing.

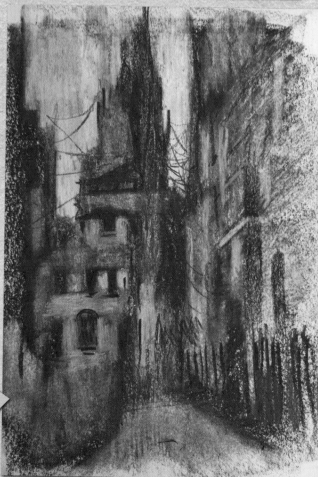

Add any finishing touches to complete.

CHAPTER 7

A DIGITAL WORLD

Drawing with one of the drawing/painting apps now available is not only great fun but also very useful. These days, most of us have a phone that we carry with us most of the time. So you can use it to make quick sketches to amuse yourself on the station platform, sitting at the back of a bus, or in a doctor's waiting room – anywhere, in fact. Best of all you can remain invisible, as most people just won't notice that you are drawing!

Apps are relatively inexpensive and it is possible to save a drawing and swap it between apps. Just experiment to find which app you like using best.

NIGHT SCENE: PART 1

By building up layers of colour on a tablet you can make objects look as though they are glowing from within. This is great for painting night scenes.

Materials:
- Tablet
- Drawing/painting app
- Finger or stylus

As this is a night scene, I start by painting in the sky, using several different shades of blue. I like to add layers of blue so that the sky isn't too flat.

These apps allow you to work in layers of interchangeable styles and colours. This new layer changes the brushes option to an ink line, and the colour to yellow ochre so I can start drawing the building.

Use darker brown for the opposite side of the road. These buildings are lit with reflected light and neon lights.

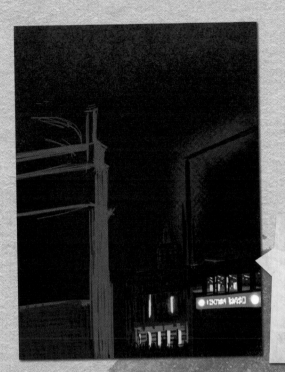

To create diffused light around the big billboard I have added some red light to a layer that will go underneath the drawing of the buildings. Then back to the top layer again to continue adding detail.

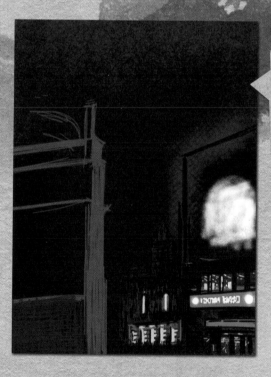

I am using the ink line for some of the detail and then using a pastel on top for the billboard.

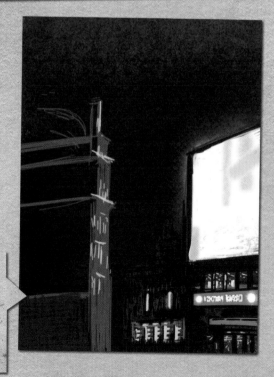

Add some highlights to the building in the foreground and fill in the billboard screen fully.

Continued overleaf...

81

Start working on the left hand building now. The use of broken lines adds texture and interest to the drawing.

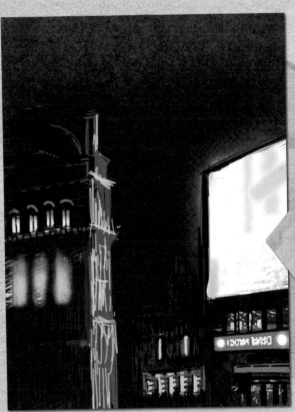

Start drawing in the windows. Notice how the lights inside the building give it added depth.

Add detail to finish off the row of smaller windows at the top.

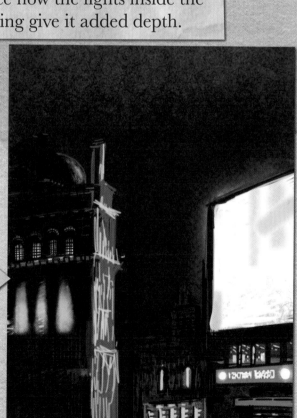

ARTIST'S TIP:

Try to keep your work looser.
Concentrate on the visual effects
rather than detail.

Add more highlight
effects as created by the
illuminated billboard.
Then add a red glow
to the doorways
(bottom left).

Add some
additional detail
to the doorways
in the foreground
and any last
finishing touches.

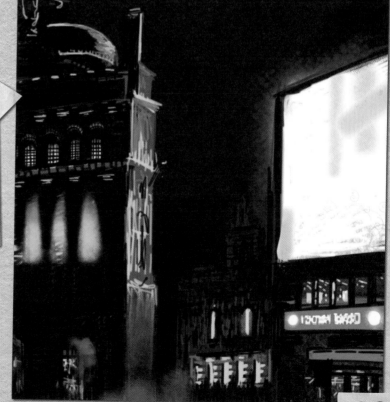

CITY OF THE MIND

Doodling is a good way to get used to using drawing apps. Try drawing a city from your imagination. Look at the work of Paul Klee, Wassily Kandinsky, or M.C. Escher if you need inspiration.

Start with a texture in the colour you want for the background. Then suggest the shape of a city-like outline in a darker tone.

Add more building shapes, a few windows and the sun.

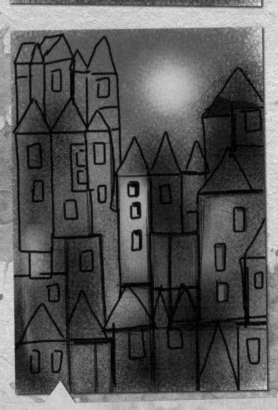

Draw in constructed black lines for the buildings.

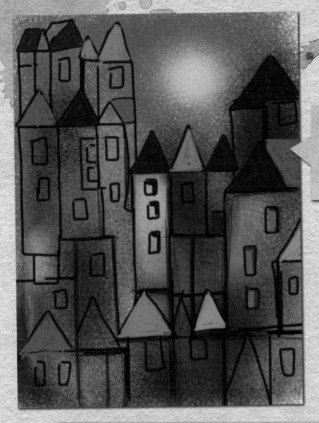

Add colour to the rooftops, using colours in the same range.

Now colour in all the buildings and windows. Think about the colours you use and how they complement one another.

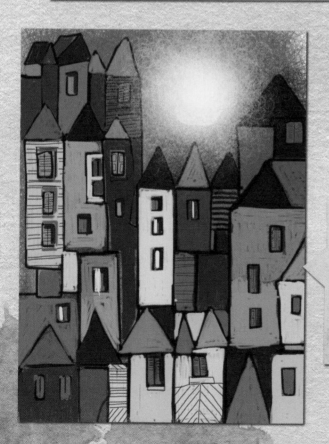

Add any finishing details to the buildings and the windows. Make a new top layer and diffuse the light of the sun so that it spirals out over the rooftops.

COMBINATION DRAWING

Drawing apps can be very useful in other ways. I made a start on this drawing in the traditional way, then photographed it with my mobile phone. Once imported into a drawing app, I then finished it off digitally.

Materials:

- Paper/sketchbook
- Watercolours
- Tablet or smartphone with drawing app
- Finger or stylus

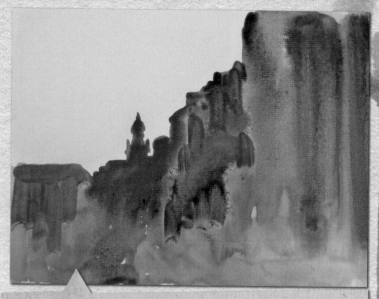

Paint in the shape of the buildings against the skyline. Remember to use the negative space to help you get it right.

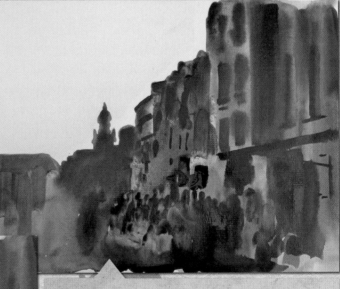

Indicate the crowds in the foreground and the windows using prussian blue on top of burnt umber.

Use pastels for the sky and the sun. Let the sunlight spill over the buildings a bit.

Add some touches of light to the buildings and around the figures, using pastels.

Now take a photo on your phone and import it into your drawing app. Add more colour to the sky digitally with a pastel type brush. Start a new layer and add some dark shapes with a flat ink brush and some touches of dark pastel.

Draw in some of the figures with a digital charcoal stick. Add long shadows.

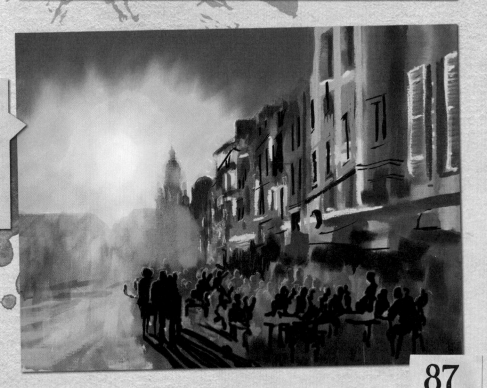

This is a very interesting and useful way to work. If you are heading off on holiday you can use the internet to check out some views that you might want to sketch there. Alternatively, like me you may just fancy the challenge of sketching somewhere new. Today, online, I am visiting Harlem in New York.

Materials:

- Technical ink pen (01)
- Fountain pen with blue writing ink
- Ink dip pen
- Indian ink
- Watercolour paper
- Watercolour brushes
- Watercolours: burnt sienna, yellow ochre, sap green, french ultramarine blue

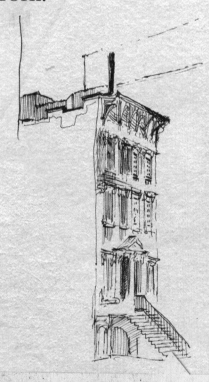

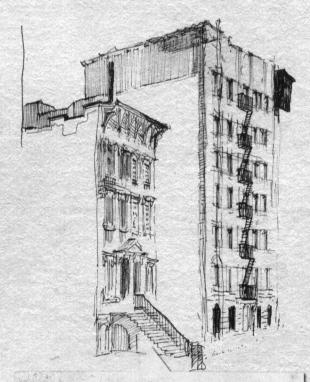

I started drawing in the roofline of the small middle building using a technical ink pen. The windows are in a grid formation, so are easy to plot out.

Draw in the second building. The fire escapes in this area are very iconic and easy to draw if you take them step by step. Draw the balcony platforms first then connect them with staircases.

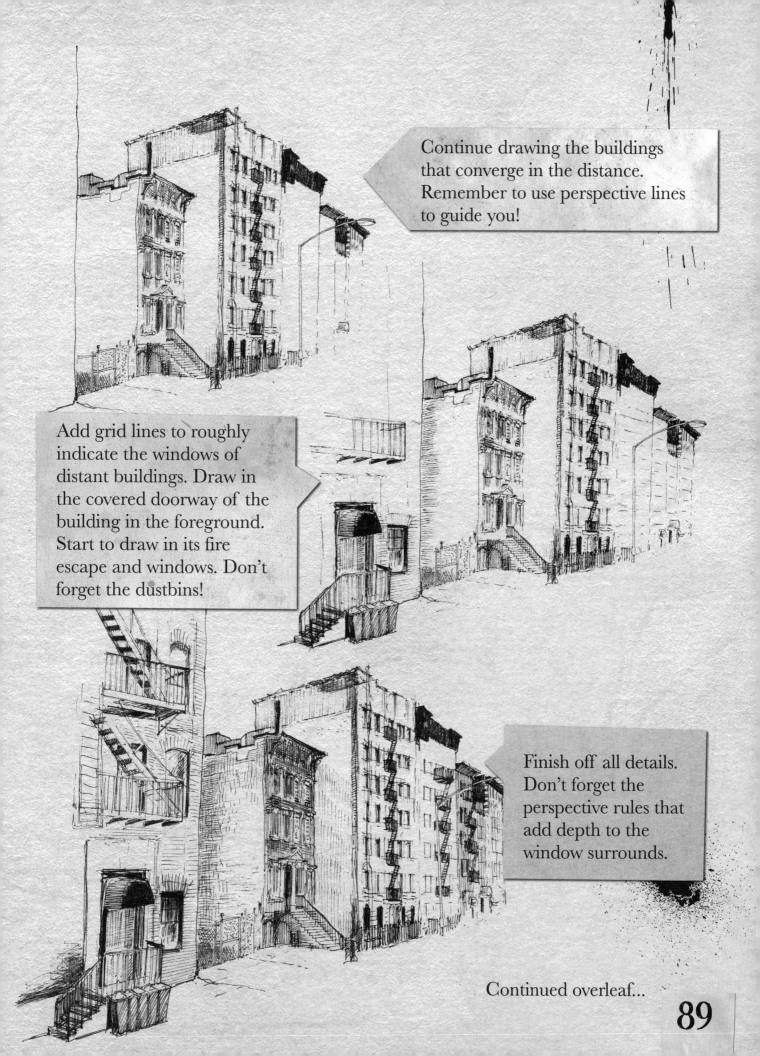

Continue drawing the buildings that converge in the distance. Remember to use perspective lines to guide you!

Add grid lines to roughly indicate the windows of distant buildings. Draw in the covered doorway of the building in the foreground. Start to draw in its fire escape and windows. Don't forget the dustbins!

Finish off all details. Don't forget the perspective rules that add depth to the window surrounds.

Continued overleaf...

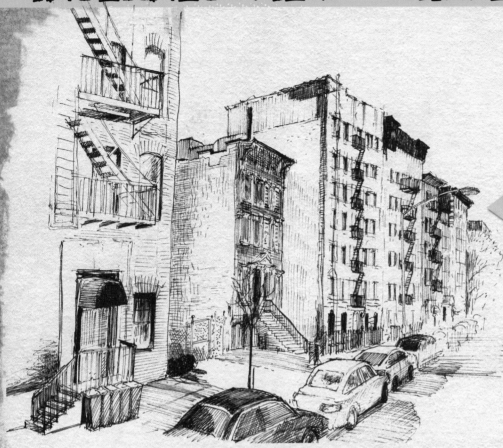

Now think about adding parked cars and shadows.

Change to the dip pen to go over some lines. Then using a wet brush and clean water, add some loose washes.

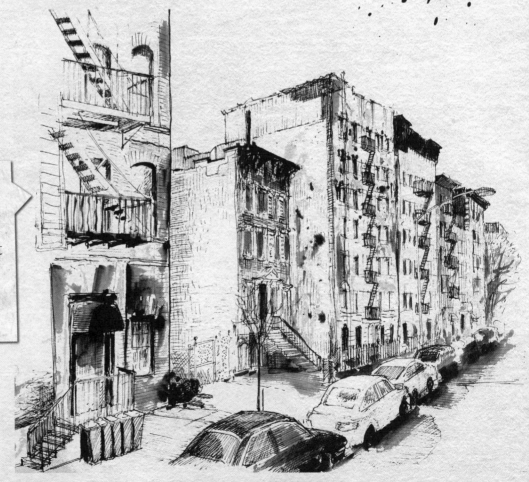

Make sure that the details on the buildings become less defined as they recede into the distance.

The addition of a moody sky creates atmosphere. At this stage I start using the fountain pen for some blue washes.

To finish, I have added a bit of colour using watercolours. Go over any areas that seem to have got lost in this process by making lines stronger again.

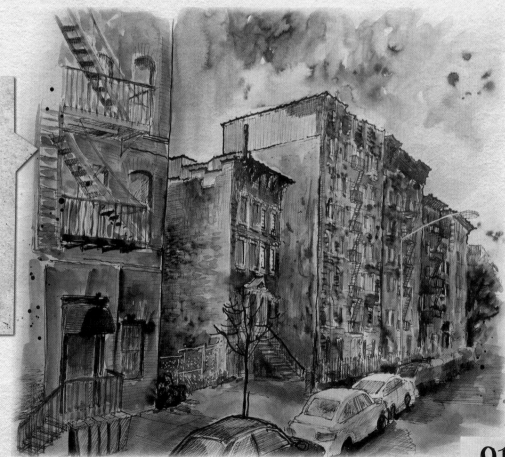

INTERNET VIEW - VENICE PART 1

T his time the internet takes me to Venice, where I virtually wander the length of the canals on street view until I see something that takes my fancy. If you 'drop a pin' to bookmark the spot, you can return to finish it later if you want.

Materials:

- Paper
- HB Pencil
- Graphite stick

I started with the building in the centre background. I like using a varying line, adding little pressure points every now and then.

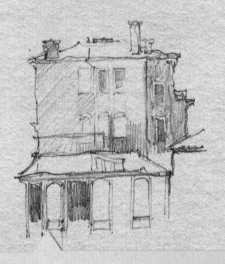

Lightly draw in the windows. Be alert to architectural details like the plaster work surrounding the shuttered windows and the varied roof shapes.

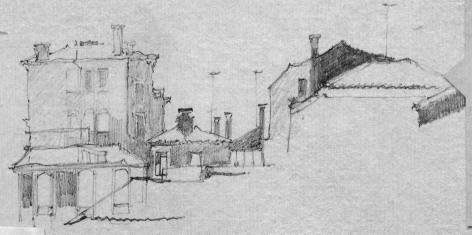

Continue along the roofline. I have included aerials as I like the way they break into the skyline. Start to shade in some darker areas. Slight variation in pencil pressure creates interesting fluctuations in the lines.

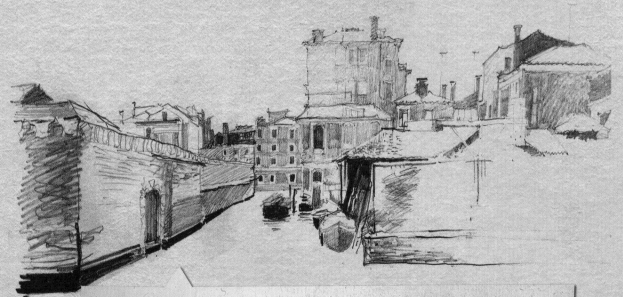

ARTIST'S TIP:

Allow your pencil line to squiggle, wiggle and make patterns to create the elements of this scene, rather than laboriously copying it!

A scene like this can look very complicated but keep calm - just stop, look and draw. It doesn't matter if you make a mistake, just keep drawing.

Now add some nice bold dark lines, down by the water's edge.

Doodle your way around the buildings and just let the scene build up gradually.

Continued overleaf...

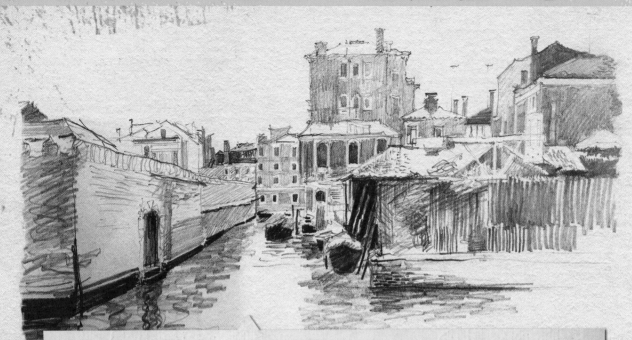

Finish darkening any areas and add wiggly lines for the water. Note that the reflections fall directly below the door and walls.

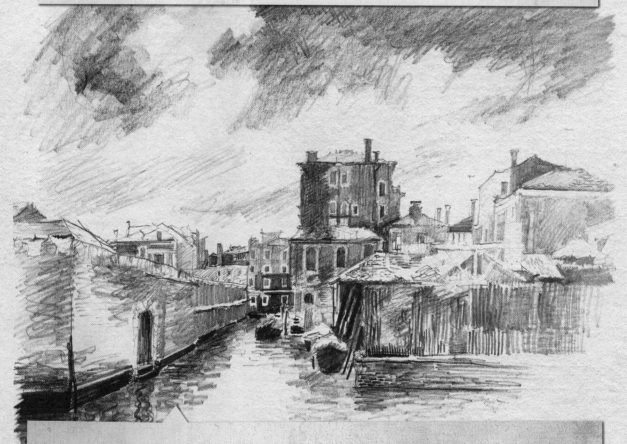

Draw in a moody, atmospheric sky and check all shadows. Add any remaining details to finish!

CHAPTER 6

EXPLORING THEMES

Explore urban landscapes and discover what themes interest you most. There are many aspects to consider. Do you prefer wide panoramas...or details? Day or nighttime scenes? Quiet locations or those bustling with activity? Natural or electric lighting? Your choices are endless and each aspect offers its own challenges. Overcome these through your composition and exploration of materials and mark-making.

Always remember:
• Look more at your subject and less at your paper.
• It's your creation – you are the boss!
• Practice will make you an artist – it's up to you!
• It's okay to use photographs.
• Enjoy what you are doing.

Drawing architectural details is always interesting. They often look very complicated but just take it steady and follow your eye around the subject – it will build up slowly. Try starting with a quick sketch of some architectural detail and then developing it into a larger oil painting.

Materials:

- Black marker pens (various sizes)
- Primed linen stretched canvas (80 x 60 cm)
- Oil paint
- Turpentine
- Brushes

This first sketch has all the detail that I need to scale it up for a bigger painting. You can see how the canvas has been squared up and the composition mapped out with a diluted mix of burnt sienna and ultramarine blue oil paint. Then I made a start blocking in large areas.

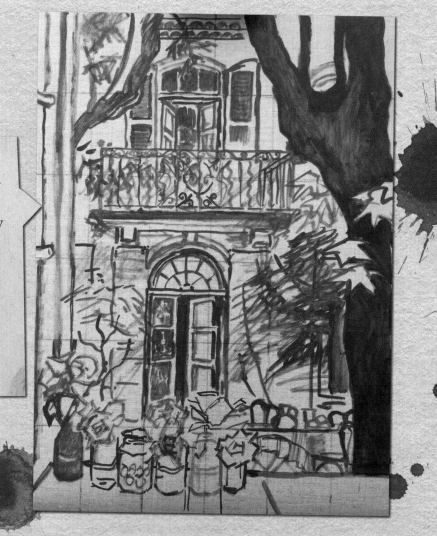

ARTIST'S TIP:

One of the benefits of oil paint's long drying time is that you can merge colours at a later stage if needed.

Block in all the darkest areas and then the remaining base colours. These base colours will be overpainted but might show through in areas.
Add form to the roses in the foreground, working the colours into each other. Don't forget the shadows on the windowsill.

Note how the texture of the tree trunk is built up by overpainting. Add touches of colour for the tree foliage.

Continued overleaf...

97

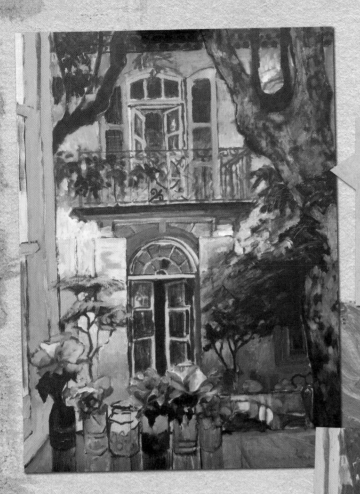

The scene is bathed in sunlight but I have added cooler shadows around the table area where it is shaded by foliage. I have painted a purple red glaze over the large tree trunk.

At this stage I start tightening up any details like the table, chairs, tablecloth and the rose jars. Start to add highlights to the foliage where sunlight hits it.

ARTIST'S TIP:

Accentuate some areas of your painting but let other areas recede.

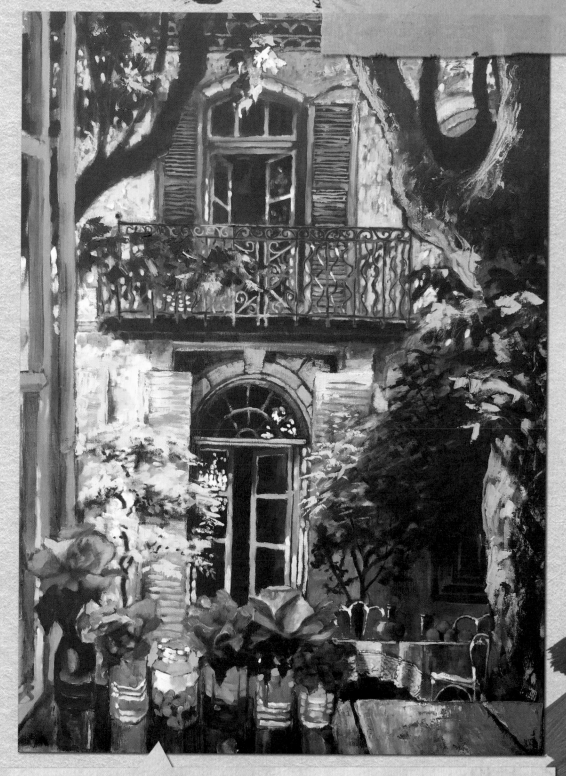

I have painted some areas darker and added more highlights. Don't forget the reflections in the glass. The louvred shutters have been overpainted and the paint lifted off with a toothpick to create slats.

This pen drawing is not dependent on a varied ink line. It is a very graphic drawing style. The interest is created by careful pattern-building, followed with a watercolour wash to finish.

Materials:

- HB pencil
- Technical ink pen (02)
- Watercolours: yellow ochre, burnt sienna, potter's pink, Naples yellow, Phthalo green
- Watercolour brush (round sable)
- Smooth paper

I have marked out some of the roof tops and house shapes that will be in this drawing.

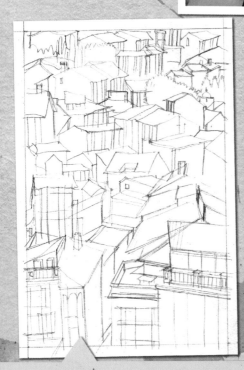

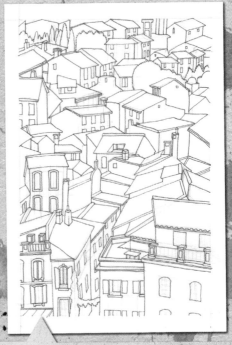

Use a light pencil line to draw in the shapes of the houses. Note the architectural style, roof and window shapes. Pay particular attention to the directional juxtapositioning of shapes.

Start to define the outlines with a fine ink pen. Do not be tempted by detail yet – keep to linear shapes only.

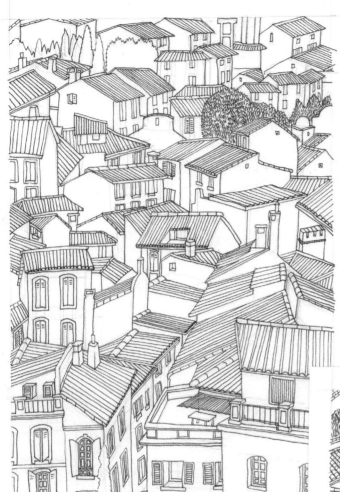

ARTIST'S TIP:

This style is very effective but can feel like 'knitting' a drawing. It's probably best to do it in stages or it may drive you mad!

Now start to draw in the details: individual tiles, shutters, window bars and balconies. Use different patterns for everything: bricks, leaves, tiles. Make sure all your marks are linear – do not add any tone yet!

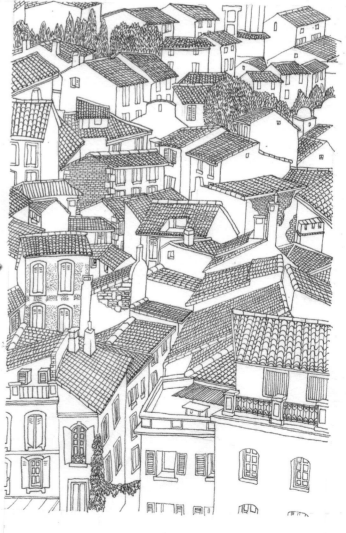

To stipple areas (little dots), hold your pen vertically or you'll create a tail on each dot.

Continued overleaf...

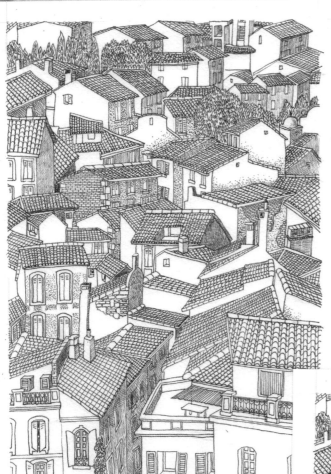

Use a limited amount of fine cross-hatching, or light stippling to suggest shadows where necessary. Choose your light direction first to decide which areas are in shadow. This will add a 3D aspect to the drawing. If you feel unsure, lightly shade in with a pencil first.

Now darken the windows. Notice that the inner sill is visible in some of the closer windows. This adds a sense of depth. Now check that all the shadows are in the right place, there is enough detail and that you are happy with the drawing. Then gently erase all the pencil lines.

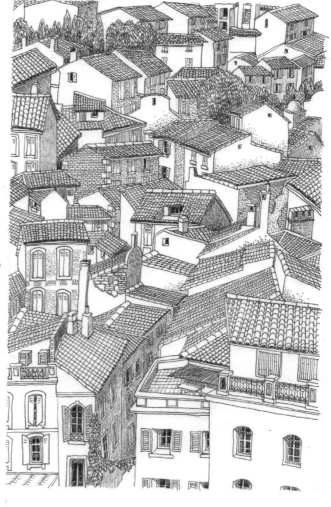

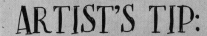

ARTIST'S TIP:

Don't overpaint. Use a very light touch and keep your colour clean at all times.

Start adding colour to the drawing using light watercolour washes. This palette is predominantly earth colours, based on the colours generally seen in this area. Note the limited use of very soft greys and pinks, too.

HAT SHOP

Shop fronts and window displays make fascinating subjects. The range of shops, merchandise and displays form an endless source of variety. Like still life compositions, they are just waiting to be painted.

Materials:

- HB pencil
- Technical ink pen (02)
- Watercolours: yellow ochre, burnt sienna, potter's pink, Naples yellow, Phthalo green
- Watercolour brush (round sable)
- Smooth paper

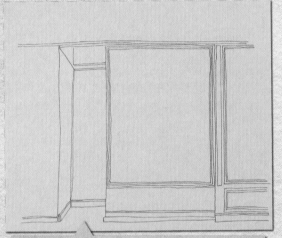

Start inking in the window space and the door frame.

Add more panels and moulding to the adjacent window and the doorway.

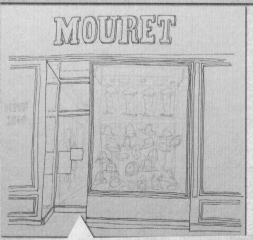

Lightly pencil in the shape of some of the items in the window display. Add reflections to the paintwork.

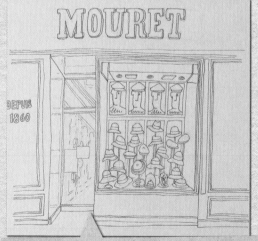

Pencil in the window display in more detail (hats, in this case) and also the lettering above. Ink in the pencil lines.

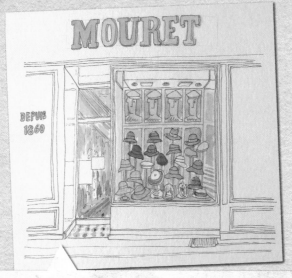

ARTIST'S TIP:
Watercolour painting is a combination of 'the intentional' and 'the accidental'. You have to judge when to control paint and when to let it make its own mark.

Start painting using the lightest tones first. Don't feel you have to stick within the inked lines as you will be building colours up.

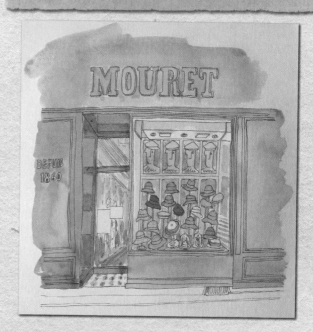

Let these areas dry. Now, using clean water, wet the areas that you want to paint green and start flooding in green washes.

Do not worry about any pooling of colour or uneven blotches. This adds charm to your painting. Deepen colours by applying more paint, but allow the paper to dry first. Run a wash of grey along the pavement and add any finishing touches.

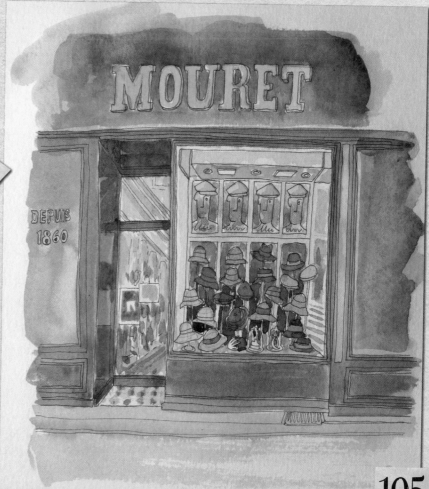

BAKERY

Try painting on black paper with gouache paint – it's a quick and easy way to achieve a bold result. The black background makes the colours sing and drawing with a white pen makes you approach your subject in a slightly different way. You could also use pastels for this technique.

Paint a page of your sketchbook black. Let it dry.

I started by drawing the shop window and then the bike in front of it. In reality I'm actually drawing the highlights of the bike!

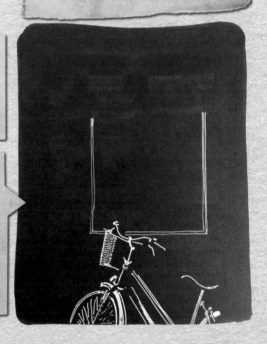

Draw in the whole window frame, including the half closed shutter.

Draw in the window shelves. Mix some grey gouache then start painting (as shown).

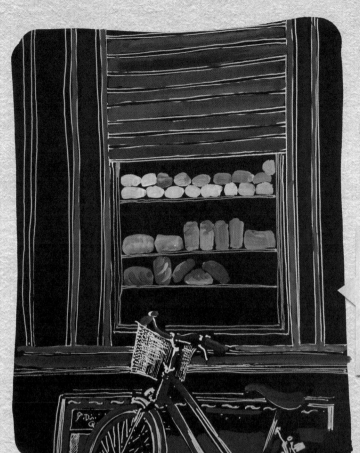

ARTIST'S TIP:

You can use gouache in different ways. If you want areas of flat, matt colour, mix it into a creamy consistency before you apply it.

Use various mixes of white and yellow ochre to make different shades to paint in the baker's produce.

Add more floury loaves and currant buns for interest. Add a touch of background light and some dark red for the shop front. That's it...now you can paint any subject you want in this style!

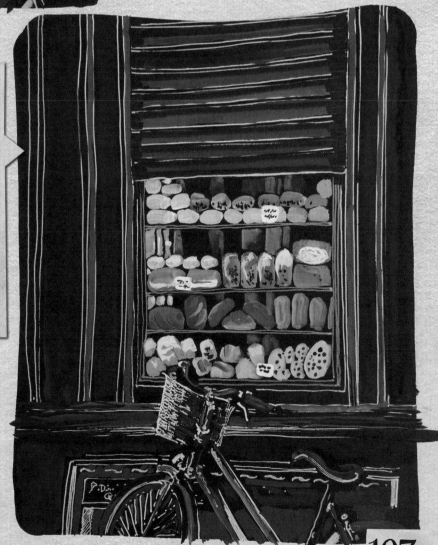

107

MARKET STALL STILL LIFE

A city market stall makes a great subject. It is full of interest and lots of colour. There are so many varied shapes and often wonderful repeated patterns.

Materials:

- Watercolour paper 265 gsm
- Pencils HB, 3B
- Watercolours
- Brushes

Start by lightly pencilling in a selection of pumpkins, a box of chestnuts and the tableful of boxed figs, plums and cherry tomatoes.

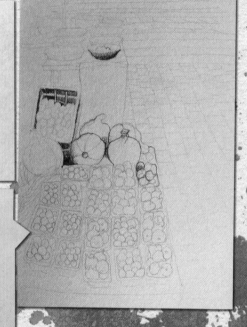

Then draw in the cobblestones and the table in the background with bowls of olives. Start picking out some of the shapes with bolder lines.

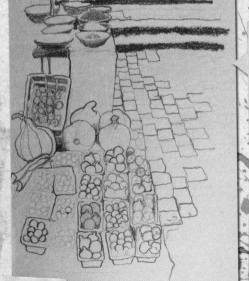

Strengthen the pencil line throughout, including the shapes and patterns made by the fruits and vegetables.

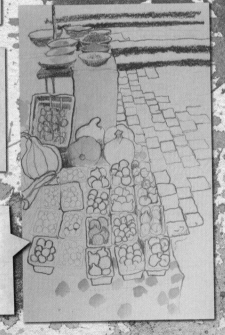

Start dropping in washes of colour. Always apply the lightest tones first.

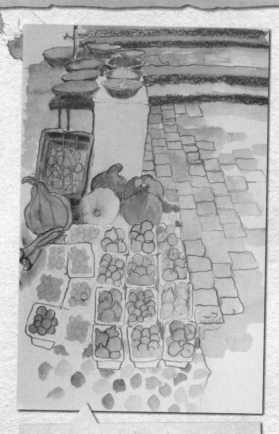

ARTIST'S TIP:

Watercolours need a light touch – do not overwork. Test out colours on scrap paper before applying colour to your painting.

Continue adding more colour washes using some nice warm oranges with burnt sienna added.

Mix burnt sienna and french ultramarine to make soft pinkish greys to paint the cobbles.

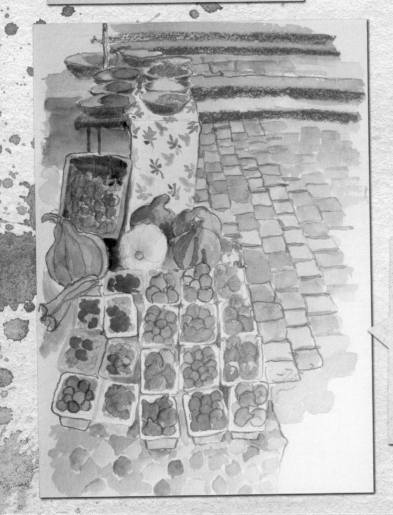

Finish adding colour to all the little boxes of fruit (leave the boxes white). Add a few layers of colour to areas that need strengthening. Then check for any finishing touches and add patterns to the tablecloths.

REFLECTIONS PART 1

Reflective surfaces and unusual shapes test your observational skills. Urban landscapes are full of these tricky subjects. Look carefully and draw what you see. Imagine that your drawing is going to another planet as a reference to build a duplicate of your subject. Make every line informative!

Materials:
- Paper (265 gsm)
- Pencils HB, 3B and 6B

Start anywhere. I decided to start at the base of the reflective sphere. It is made of panels, and these form lines which make it easier to plot out the spherical shape.

As the drawing progresses, I add tone to the building behind. This is called "using lost edges". This use of background tone shows the edge of the sphere without the need to contain it by a hard outline.

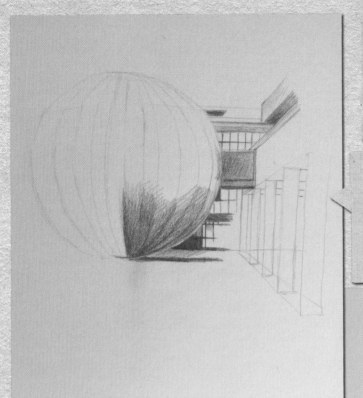

ARTIST'S TIP:

If you remember tonal values and perspective lines your drawing will work out.

At this stage I start to plot out the whole sphere. I also concentrate on the geometrical shapes of the building behind, and the perspective lines for the pillars.

Draw in the wall and pillars. Add more tone to the reflections.

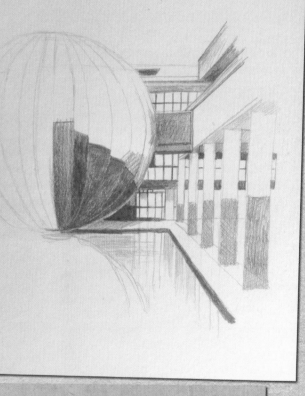

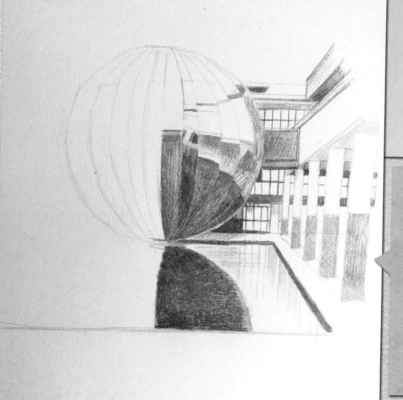

Draw in the reflection in the water under the sphere. Reflections are usually darker and slightly less focused than the object itself. Look carefully at the sphere now and start to build up its reflective surface using various tones.

Continued overleaf...

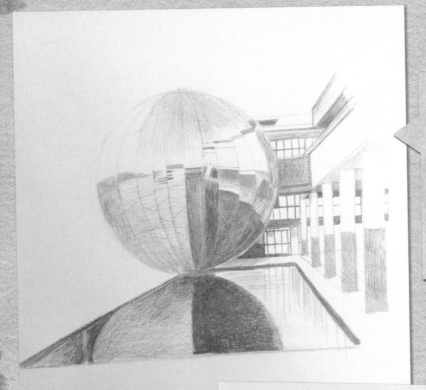

The lines of the adjacent paving stones are reflected in the sphere. They look like cracks in the mirrored surface. Finish off the whole sphere now.

Adding in the rest of the background helps to place the sphere and also defines its scale.

ARTIST'S TIP:

Adding a figure to this scene would be an easy, instant way to define its scale.

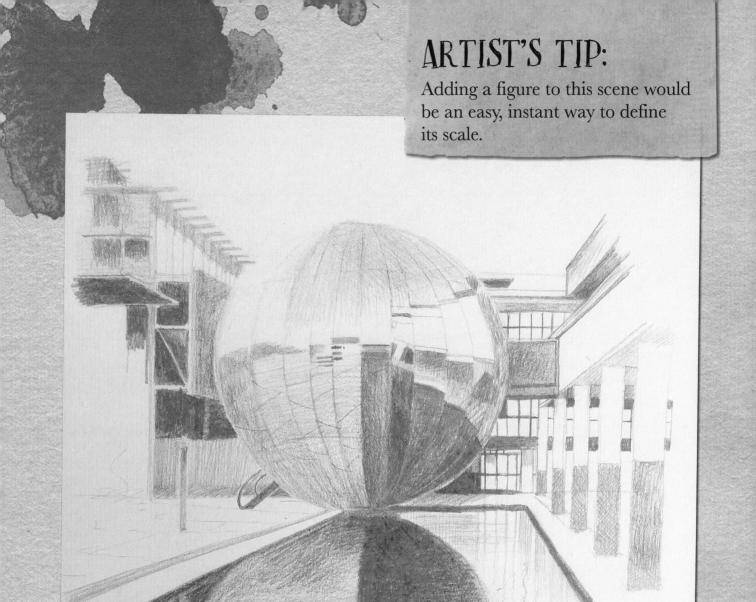

These kind of subjects are difficult to draw and can end up looking really quite odd. However, tackling a subject like this is a very good exercise in drawing.

OLD WINDOW PART 1

This is a pastel painting with a watercolour base. Old windows in textured walls make wonderful painting subjects. Dry or chalky pastels are a very useful tool to quickly add areas of colour. Pastel drawing is a good way to plan an oil painting as many of the techniques are similar, but pastels are a great medium in their own right.

Materials:

- Mounting board
- Selection of soft pastels
- Watercolours: yellow ochre, burnt sienna, french ultramarine.
- Brushes

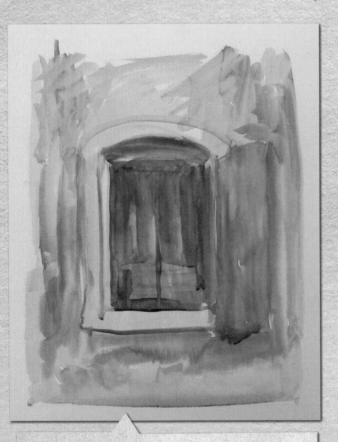

Start by applying very loose watercolour washes. This forms the base colours that will make the pastel tones richer and stronger.

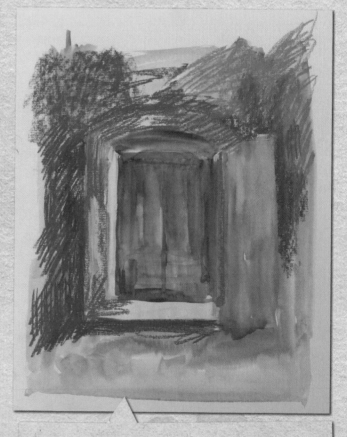

When the watercolour wash is dry, start scribbling in colour. I used several shades of burnt sienna, some yellow ochre, and purple for shadows.

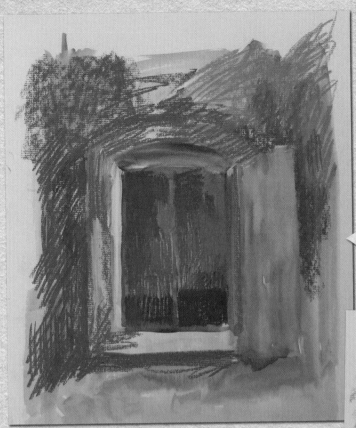

ARTIST'S TIP:
Use the back of your hand to test if a watercolour wash is dry or not. If it feels cool, it may still be too damp to work on.

Add more colour to the window now. No glass window has only one colour in it, so use a variety of blues and dark greens.

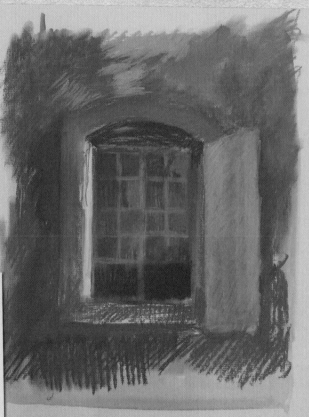

Blend the colours together. I used my fingers but you can use a paper stump. After blending, draw in the window bars. Blend some more.

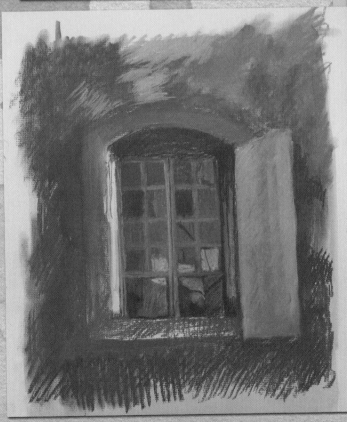

Pick out some detail in the window pane, like the reflection of the building opposite. Add little highlights using the sharp edge of a pastel. A touch of prussian blue added to the top and right hand window recess cools down the browns and gives depth to the shadows.

Continued overleaf...

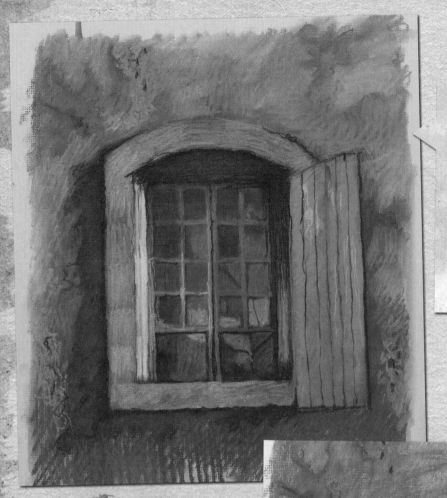

Finish blending then add some sharper lines using the edge of a pastel or a pastel pencil. Scribble lighter colour onto the wall to add texture and add lines on the wooden shutter.

A light spray of fixative at this stage will make the colours look darker but don't panic – it will lighten again as it dries.

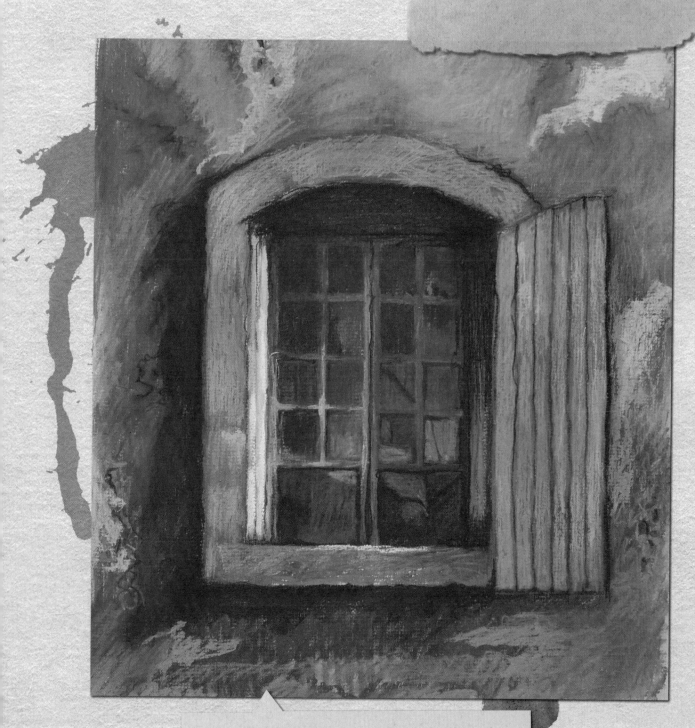

Once fixed, I add some final dashes of colour – mainly some highlights added to the sill and shutters.

EARLY MORNING PART 1

An early Sunday morning, in the middle of winter, is a perfect time for some 'plein air' watercolour painting. Street lights are still on but the sky is interesting, it is light enough to see what you are doing and…there is hardly anyone about. No interruptions and no uninvited advice!

Materials:

- Multi media paper (265 gsm)
- Water-soluble pencils: sienna gold, shiraz
- Watercolours: quincridrone gold, quincridrone magenta, ultramarine violet, indigo, burnt sienna, Vandyke brown, Payne's grey, cadmium yellow and cadmium red
- Brushes

Loosely draw in the skyline and some of the lights using the sienna gold pencil. Add some more lights and some of the reflections with the shiraz pencil. Then wash over the drawing with some clean water.

Add a light wash of quincridrone gold and magenta to the sky.

ARTIST'S TIP:

'Muddy' water makes 'muddy' colours. Carry a supply of water.

Add touches of ultramarine violet to some of the buildings. Apply a light wash to show the colours of the sky reflecting on the river.

Now add a wash of indigo to the sky, the buildings and the foreground of the river. Notice how messy and sloppy it is all looking but just ignore that and let everything dry.

Using Vandyke brown and Payne's grey, start adding definition to the buildings.

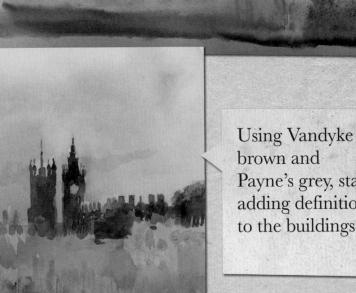

Continued overleaf...

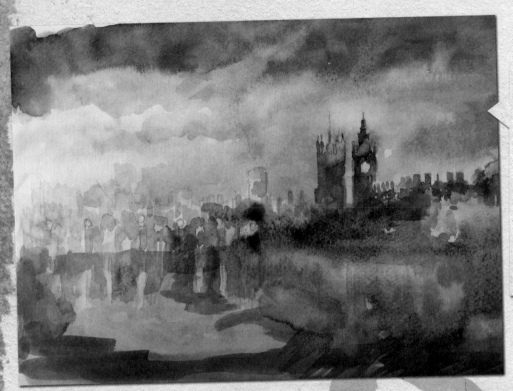

Carefully add more washes to indicate the shapes of the buildings. Apply darker washes of violet, Payne's grey and indigo to the top of the sky and the foreground.

When it's dry, add more of the same wash to apply bold, directional brushstrokes to the sky. This creates a sense of dramatic light. Add more quincridrone gold into the reflections.

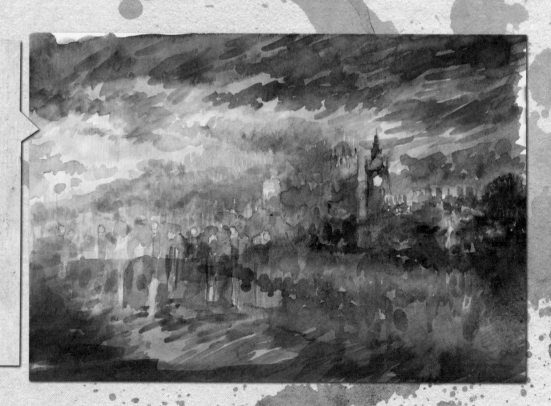

Taping the edges of your paper to a drawing board will help to minimise any buckling that might occur.

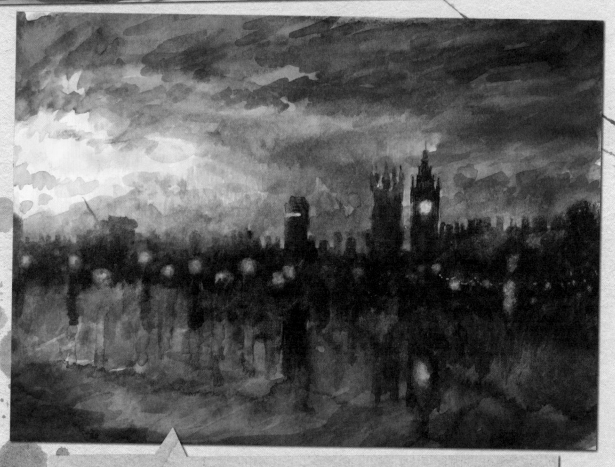

Add weight to the buildings by painting them with Payne's grey. Take care not to paint over the lights. Allow to dry.

At this stage, I wet the painting with clean water to soften edges. Finally, when it's all dry, dot in a few more lights using cadmium yellow and cadmium red.

PAINTING AT NIGHT

For a successful night painting or sketching trip it is really worth organising and familiarising yourself with the colours on your palette or the colour arrangement of your pastels. In low light, you will find it easier to reach for colours instinctively rather than making colour judgements.

Materials:
- Gessoed board
- Oil paint: prussian blue, alizarin crimson, indian yellow, titanium white
- Several brushes
- Toothpicks
- Turpentine

Block in most of the night sky using a brush fully loaded with a mixture of alizarin crimson and prussian blue. Leave a small patch of white for the streetlight in the foreground. Use Indian yellow to create the band of bright lights on the far bank and its reflections in the river.

Add a dark horizontal line for the far bank and dark areas of the river.

It's fine to let colours mix a bit, especially in the water. Block in some dark shapes on the far bank. Blend the night sky down into the yellow lights. Add a dark horizontal band to the foreground.

122

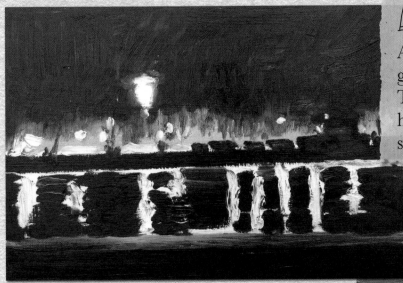

ARTIST'S TIP:

A scene can be captured with great simplicity and scant detail. Try studying your subject with half-closed eyes to reduce it to its simplest components.

Use white paint to add some further light to the illuminated far bank. Run some light down onto the river, too.

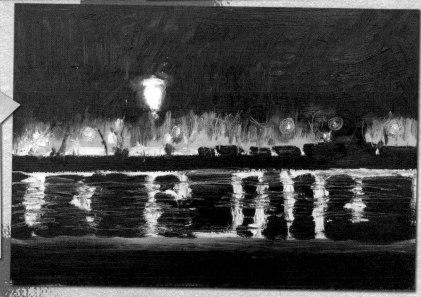

Use a toothpick or the end of your paintbrush to scratch through wet paint to create haloes around the lights and to pick out branches that catch the light. Use this technique to create movement in the river, too.

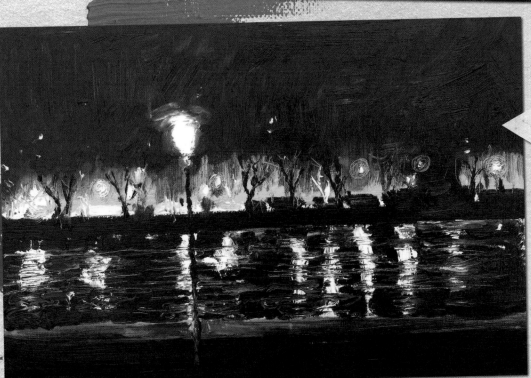

Paint in the lamp post in the foreground and some dark tree trunks on the far bank.

123

THE CITY AT NIGHT

This approach to the city at night may be slightly less daunting than using oils. Applying watercolour or gouache paints to black paper is a quick and effective way to capture the elements of a night scene. It is also a great way to make quick studies for later use in an oil painting.

Materials:

- Sketchbook
- Indian ink
- Flat brush
- White gel pen
- Gold gel pen
- Black marker pen.
- Gouache paint

Ink in a background on a page of your sketchbook. Let it dry thoroughly. Paint in the kerb and the road markings with gouache. Remember, it will dry lighter.

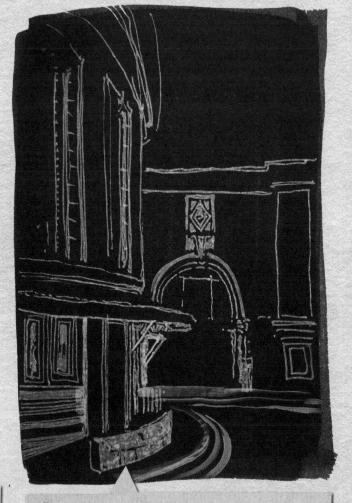

Start drawing with the white gel pen. Try to pick out the light areas but don't worry too much about it. Just get everything in place.

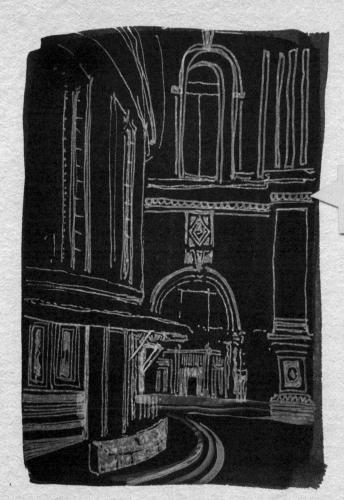

ARTIST'S TIP:

You can buy a pad of black paper to work on. If the paper is thin, use pastels instead of gouache paint.

Add as much detail as you feel necessary.

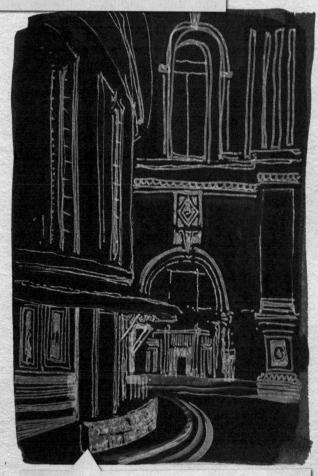

Block in areas with gouache paint. I chose a dark red colour because it shows up well against the black paper.

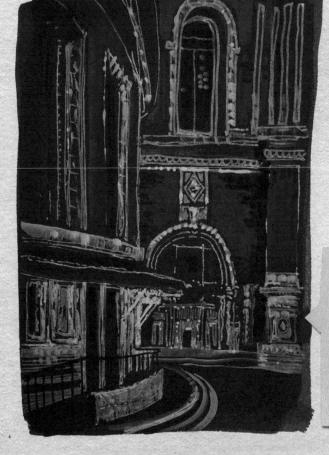

Add touches of yellow ochre and pick out smaller details with the gold gel pen. Run some cool blues over some of the white pen lines to create a sense of depth. Use the marker pen to draw in the railings and any other finishing touches.

125

GLOSSARY

Background The sections of a drawing or painting that are furthest from the viewer.

Blending The process of gently rubbing a section of shading with a blending tool (e.g., a paper stump) to evenly distribute the medium over the paper's surface.

Blind contour Line drawings produced without looking at the paper.

Canvas Coarse cloth or heavy fabric that must be stretched and primed to use for painting, particularly for oil paintings.

Colour wheel The organisation of colours on a wheel. Used to help understand colour schemes.

Composition The arrangement of various parts of a drawing subject within the borders of a drawing space.

Contour The outline of something.

Crosshatching The use of fine, parallel lines drawn closely together, to create the illusion of shade or texture in a drawing.

Depth The apparent distance near to far or front to back in an artwork.

Figure The human form in art work.

Foreground The sections of a drawing or painting that are nearest to the viewer.

Gouache A watercolour paint mixed with white pigments making it more opaque and giving it more weight and body.

Highlights Small white areas in a drawing or painting used to show the reflection of light.

Juxtaposition The placing of compositional elements side-by-side, with the intention of comparing or contrasting them.

Line The most basic drawing 'tool'. A line has length, width, tone, and texture. It can divide space, define a form, describe contour, or suggest direction.

Matte A surface texture that is dull and lustreless.

Medium The process or material used in a work of art.